PICASSO

PICASSO

Roland Penrose

with notes by David Lomas

Phaidon Press Ltd
140 Kensington Church Street, London, W8 4BN

First published 1971
This edition, revised and enlarged, first published 1991
Second impression 1993
© Phaidon Press Ltd 1991

A CIP catalogue record of this book is available from the British
Library

ISBN 0 7148 2708 8

Printed in Hong Kong

The publishers wish to thank all private owners, museums, galleries
and other institutions for permission to reproduce works in their col-
lections.

Cover illustrations:
(front) *Women Running on the Beach* 1922. Oil on wood, 34 x 42.5 cm.
Musée Picasso, Paris.
(back) *Head of a Sleeping Woman*, 1932. Oil on canvas, 53.3 x 44.4 cm.
Tate Gallery, London.

Preface

Roland Penrose, author of the introduction to this volume, was acknowledged as England's foremost authority on Picasso. The story of his involvement with the artist is – like a cubist painting – many faceted.

Penrose met Picasso in 1928. When he came to write a biography, *Picasso. The Life and Work*, in 1954 Penrose was able to draw upon their lengthy friendship for many of his valuable insights. A humorous instance of this is his revelation that Picasso grafted the snout of his Afghan hound, Kasbec, onto the face of his beloved mistress Dora Maar in portraits of her – something one could not discover without the chance to observe both at first hand! Because of his personal acquaintance with Picasso during the latter part of his career Penrose manages to avoid the blinkered dismissal of the late work that once prevailed.

Penrose does not disguise his reverence for Picasso. Curiously, though, his own art was never influenced by him. It may be that for a young artist reaching maturity between the wars Picasso – as the most famous modern artist – was more an image than a viable artistic model. After dabbling in abstraction, Penrose looked to surrealism where he was beguiled by the work and person of Max Ernst. Happily this chance encounter stimulated rather than stifled his own creativity, as might have happened had he tried to emulate Picasso.

The surrealist background is worth bearing in mind. After all, when Penrose met him Picasso had more or less thrown in his lot with the surrealists too – the evidence in his recent work would have been plain for Penrose to see. As a critic, Penrose would write most acutely about this surrealist phase. His sensitivity to a poetic and subjective side of cubism, as well as its cerebral and rational aspect, may also owe something to surrealism: André Breton, whose own esteem for Picasso equalled that of Penrose, had declared in 1936 that 'Picasso is surrealist in cubism.' After the Second World War Penrose translated a rather surreal play by Picasso, *Desire Caught by the Tail*, which was staged at a West End theatre in 1950.

Penrose was on the organizing committee of the International Exhibition of Surrealism held in London in 1936, which included several Picasso paintings. He was instrumental in bringing *Guernica* to London in 1938. Thereafter he helped organize several Picasso exhibitions under the auspices of the ICA and the Arts Council.

It was a great privilege of Penrose to be able to collect the art he admired. At a time when the Tate Gallery had only three Picassos, Penrose loaned twelve to an exhibition of Picasso in English Collections at the London Gallery in 1939. These had mostly been purchased from a Belgian dealer René Gaffé and the surrealist poet Paul Eluard. But the gem of the collection, the *Weeping Woman*, was bought while the paint was still wet directly from Picasso.

Art collecting is usually a private affair. It is a fitting tribute to the

public spirit of Penrose, however, that the *Weeping Woman* now hangs in the Tate. Close by is the *Three Dancers* which Penrose, on behalf of the Tate, persuaded Picasso to part with for a knock-down price. Significantly, these two great masterpieces mark the beginning and the end of Picasso's intense dialogue with surrealism. It would have been a source of pride to Penrose that works by himself hang in the same room.

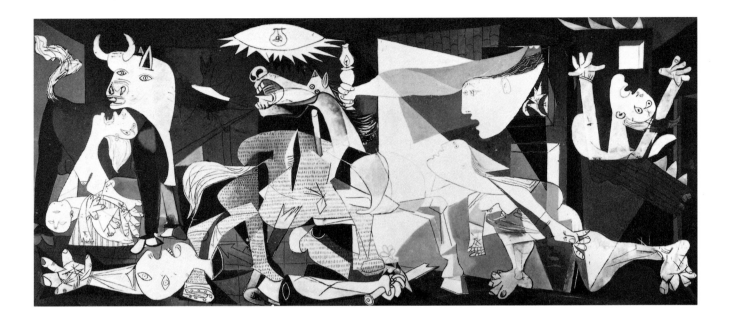

Introduction

The name which predominates in the development of the arts during this century, and to which the most revolutionary changes are inevitably ascribed, is that of Pablo Picasso. It is, moreover, largely due to him that the conception of art as a powerful emotional medium, rather than a search for the perfection of ideal forms of beauty, has become accepted among the artists of our time

The return to a fundamental belief that art should spring from a primitive need to express our feelings towards the world around us in strong emotional terms makes us more prone to value a work of art for its vitality than for its perfection. It is the exceptional power of Picasso's work that compels us, in return, to discover in it the mysterious presence of beauty.

Early in life doubt, and dissatisfaction with academic formulas, brought him to discover that a search for beauty according to the standards in which he had been brought up was not the aim he wished to pursue. The brilliance of his talent as a youth and the ease with which he absorbed the work of other great contemporary artists could have tempted him to become satisfied with the success that came to him at last after years of poverty in Barcelona and Paris, but the strength of his powers of expression coupled with an unusual degree of courage brought a crisis which forced him to abandon the easy road to fame and plunge perilously into new forms of creation.

The turning-point in Picasso's early career came when he was 25. The struggle in which the young artist found himself involved is forcibly illustrated in the great picture, *Les Demoiselles d'Avignon* (Plate 15), painted in Paris in the spring of 1907. It came as a shock to his friends that he should abandon a style that they had grown to love and produce instead a form of art that they could no longer understand. No one, not even Matisse, Braque and Derain, nor his devoted patrons, nor even his close friend and admirer Guillaume Apollinaire could stomach this work, which at first sight seemed to them outrageous. It took many months to digest this insult to their sensibility, but gradually they came not only to accept it but to find that it was exerting a profound influence on them. Apollinaire, when he realized the significance of the change that had taken place in the artist as well as in his work, wrote a description of the difference between two kinds of artists: those who follow their impulses and show no signs of struggle, who 'are like a prolongation of nature' and whose works 'pass in no way through the intellect', and other artists who, in solitude, 'must draw everything from within themselves'. 'Picasso', he states, 'was an artist of the former kind. Never has there been so fantastic a spectacle as the metamorphosis he went through in becoming an artist of the second kind.' (Guillaume Apollinaire, *Cubist Painters* [English trans.], New York, 1944.)

This courage to explore the unknown, which has never forsaken Picasso, led in the years that followed to the creation of a new style,

cubism (Plates 15-25). Working in close collaboration with his friend Georges Braque, he was responsible for one of the major revolutions in the art of our time, a revolution which revised the relationship of painting to reality and widened the scope of our vision and our understanding of the world. Although since that time the work of Picasso has not always been cubist in style, the discoveries made between 1909 and the outbreak of the 1914 war (which ended his close association with Braque), have led to innumerable developments in his work and have spread their influence more widely than any other single movement in the arts. One of the main characteristics of his work is the ease with which he can vary his style and often mingle styles which might seem incompatible in the same painting. This tendency has in fact increased as time has passed and his experience in the various forms of expression which he employs grown richer. In his career it is remarkable how little of his former discoveries is lost. A visual memory of prodigious accuracy enables him to hold years of experience at his disposal, and contributes to the speed and urgency with which he is able to work. This retentiveness does not apply only to technical discoveries. He has been preoccupied throughout his life by images and events that possess a peculiar significance for him. The enveloping tenderness of maternity, the wonder of the human head (Plates 8, 13, 21, 36) the dilemma of the artist in relation to his model (Plate 48), the sacrificial drama of the bullfight, the heroism of classical myths, metamorphoses among living beings and inanimate objects, the breadth and luminosity of landscapes or the familiar domesticity of a still life (Plates 24, 42, 44): these themes have always absorbed him.

Although Picasso has lived by far the greater part of his life in France he has never forgotten his Spanish origins. Born in Malaga in 1881, he was the son of José Ruiz Blasco and Maria Picasso Lopez. He received his first instruction in the arts from his father who was a mediocre painter but who had the virtue of encouraging his son and who realized that the boy's talent, at the age of 13, already greatly surpassed his own. After early training in the academic tradition at art schools in Corunna, Barcelona and Madrid, where he passed his entrance examinations brilliantly, he rapidly outgrew the instruction that these academies were able to offer. Barcelona, where his family had settled, proved to be too provincial an atmosphere for him and he sought the more brilliant international stimulus of Paris. Even so, the habits, the temperament, and the art of Picasso are still fundamentally Spanish, and the early influences absorbed by him are not limited to the discoveries he made in Paris but spring also from the art of his native land.

Picasso's faithfulness to the country from which he has exiled himself is an example of the many paradoxes which are characteristic of his life and his work. For instance, he can convey with extraordinary tenderness the intimacy of lovers (Plate 29) and yet submit the female form to a scathing visual analysis (Plates 8, 15, 17, 43). There seems to be no limit to the distortions he can invent for the human body (Plates 20, 32, 33, 36, 43) and yet no artist has more compassion for human anguish. He is a revolutionary who understands and loves tradition, and a creator so essentially concerned with life that he is often obsessed by the grim reality of death. Novelty and invention fascinate him as they do a child, but there is also a continuity which runs throughout his work, giving it the constant imprint of his genius. His capacity to invent new styles and techniques, a gift that has often bewildered both his admirers and his critics, is not a fickle disregard for his former loves, it is rather a means of saving himself from the

sterility of repetition, and keeping us perpetually astonished at the youthfulness and penetration of his vision.

The output which has come from Picasso's untiring energy is prodigious. It is inconceivable owing to its sheer volume that the majority of his most important works in painting alone could be combined in one exhibition. Although painting is his major art, the universality of his genius extends to sculpture, drawing, etching and ceramics (Plate 47a), murals and designs for the theatre, poetry, the writing of plays, and the cinema. His enormous influence on the art of our time is due to the vigour and the lack of prejudice with which he develops these diverse means of expression. No artist can afford to ignore him and those who have found inspiration in his work are countless. No contemporary style, from surrealism or expressionism in their various forms to the most unemotional geometric abstraction, escapes his influence and in innumerable cases he is the prophet and the forerunner of new trends.

The work of Picasso is more than a mirror of our times; it opens our eyes to the future. Its vitality and its insight, its tenderness and its violence, are born of an understanding and a love for humanity. His art goes far beyond a facile enchantment of the eye. It fulfils a more essential purpose – the intensification of feeling and the education of the spirit. Picasso looks at the world with new vision, and by his art he enables us to do likewise.

1895-1901: Early Years

During his early childhood in Malaga Picasso showed an overwhelming desire to express himself by drawing and painting. He was encouraged by his father who earned a modest living as an artist and teacher of art. Paintings made in Corunna at the age of 14 show extraordinary accomplishment and a year later he began to find his place among the artists and poets of Barcelona, immersed in a *fin de siècle* atmosphere. His early dedication to the arts combined with his unusual talent led Picasso to explore wider fields and seek new influences. These he found in Paris. In 1900, the year of his first visit, he was deeply impressed by the Parisian verve of Toulouse-Lautrec, the exoticism of Gauguin and the powerful expressionism of Van Gogh (Plates 1, 2, 4). With eagerness and insight he readily assimilated what appealed to him in their styles without forgetting what he had learnt in his native country from El Greco, Velazquez and Goya. His return to Barcelona, where his family helped to alleviate his painful struggle against poverty, kept alive the Spanish elements in his work.

1901-4: Blue Period

During his visit to Paris in 1900 Picasso had found inspiration chiefly in the bright colour and the gay bourgeois life seen in cabarets, public gardens and on the race-course. On his return in the spring of 1901, after a few months in Madrid, his mood had changed and an element of melancholy, intensified by pervading cold ethereal blue tones, began to dominate his work (Fig. 2; Plates 5-8). The subject matter was chiefly drawn from vagabonds, beggars and prostitutes, the victims of society who frequented the bars of Montmartre or the streets of Barcelona. The greater part of these years was spend in Barcelona, where he found daily in the streets the pathetic figures of blind beggars (Plate 7) or poor women bowed compassionately over their children. Allegories concerning poverty, blindness, love, death and maternity were often in his thoughts (Plates 5, 6), particularly when

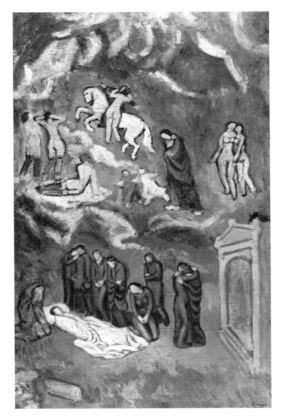

Fig. 2
Evocation (The Burial of Casagemas)
1901. Oil on canvas,
150 x 90 cm.
Musée d'Art Moderne de la Ville de Paris.

9

he was working on large compositions, and the figures, more sculptural in form than in the previous period, are given dramatic emphasis by the simplicity of their backgrounds. It has been said that at this time he was influenced by the Catalan painter Nonell. The Blue Period marks a deliberate step towards a plastic representation of form and emotional subject matter and hence away from the atmospheric effects of the Impressionists.

1904-6: Saltimbanque and Rose Period

In 1904 Picasso finally moved to Paris. He took a studio in the Bateau Lavoir, a building inhabited by painters and poets, high up on the slopes of Montmartre. The more spirited and bohemian characters of his new friends, and the company of the beautiful Fernande Olivier, led him away from the melancholy subjects which had obsessed him during the Blue Period (Fig. 3). With frequent visits from Max Jacob, Apollinaire and Salmon his studio became known as the 'Rendezvous des Poètes'. It was here that the famous banquet in honour of the Douanier Rousseau took place in 1907.

The paintings of the Blue Period had at last begun to sell to dealers and collectors such as Gertrude and Leo Stein (Plate 13), Wilhelm Uhde, and the Russian, Shchukine. The actors and strolling players of the boulevards and circuses became his friends and found their way into his paintings in tender nostalgic association (Plates 9, 11). Harlequin, who had always been a favourite character in Picasso's imagination, made frequent appearances in his compositions, often figuring as a portrait of the artist himself. The predominant blue of the preceding year gave way to gentle tones of pink and grey. The paintings of 1904 are often recognizable by elongations of the limbs that recall the mannerist style of El Greco, but by 1905 Picasso had abandoned these distortions for a classical purity of proportion. This in turn gave way to an insistence on sculptural qualities with a predominant emphasis on volume.

During these years Picasso paid a brief visit to Holland (Plate 10). He spent the summer of 1906 at Gosol, in the Pyrenees, where he painted many portraits, studies of Spanish peasants, and compositions. On his way to Gosol he had paid a visit to his family in Barcelona and refreshed his memories of the Romanesque and Gothic art of Catalonia. Even more important to him at this time was the discovery of Iberian sculpture dating from pre-Roman times, examples of which had been recently acquired by the Louvre. They attracted him by their unorthodox proportions, their disregard for refinements and their rude barbaric strength. These influences rapidly gained an important place in his work, and led to the sculptural distortions of nudes painted on his return to Paris in the autumn of 1906. During these years Picasso produced his first pieces of sculpture (*The Jester*, 1905; *Head of Fernande*; *Girl Combing her Hair*, 1906, etc.), also a remarkable series of etchings (*The Frugal Repast*, 1904; *The Saltimbanques*, 1905; *Salome*, 1905, etc.).

1907-9: Transition - The Negro Period

During the summer of 1906 Picasso met Matisse at the house of Leo and Gertrude Stein. Matisse had been acclaimed as the leader of the Fauve movement and his great picture, *La Joie de Vivre*, had been exhibited that spring at the Salon des Indépendants. Picasso, who at that time refused to exhibit in large group exhibitions, was nevertheless highly conscious of the revolutionary violence in the paintings of the Fauves, and held Matisse, Derain and Braque in great esteem.

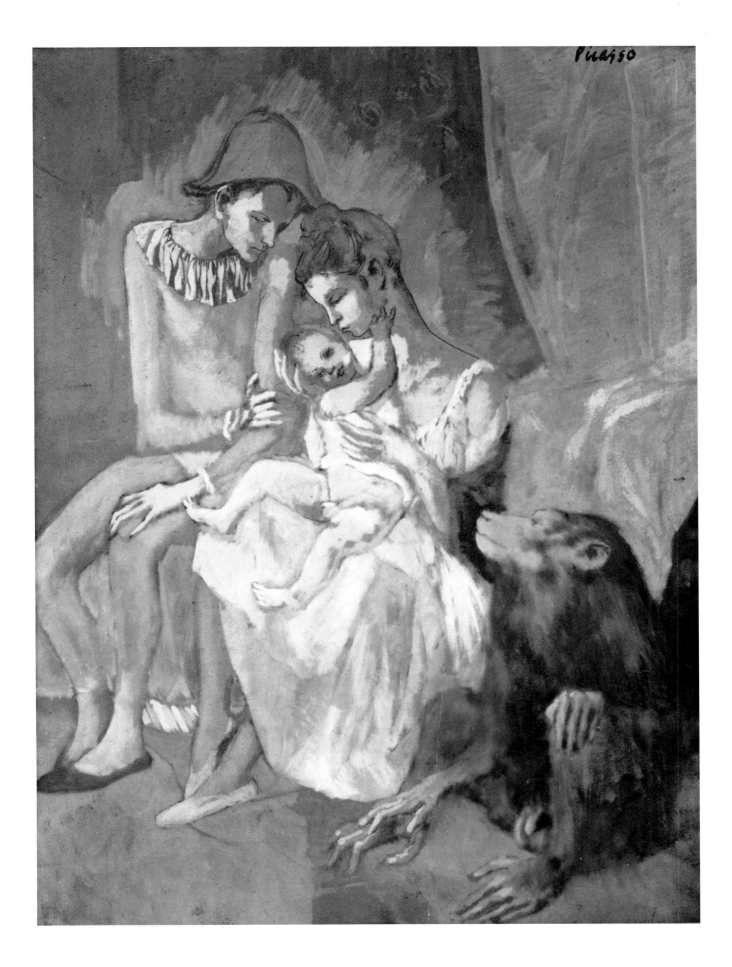

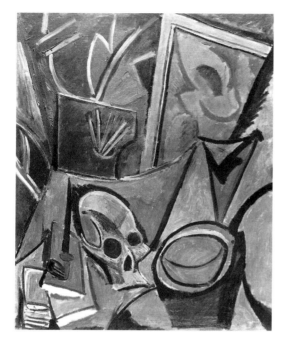

Fig. 4
Still Life with Skull
1908. Oil on canvas.
115 x 88 cm.
Hermitage Museum,
Leningrad.

However, their tendency to insist in their work on the sole importance of colour appealed to Picasso no more than did the search for representation of atmospheric effects practised by the Impressionists. At the same time there were other influences at work. The painting of Cézanne had become familiar to him through the dealer Ambroise Vollard who had given him his first exhibition in Paris in 1901. Cézanne's search for a valid interpretation of form and the geometric basis of his compositions had impressed the young Spaniard who desired to create a tangible, three-dimensional quality in his painting. Picasso had also discovered the greatness of an obscure old man, the Douanier Rousseau, the fresh vitality of whose work corresponded to Picasso's desire to discover new forms of expression. These were the years when the power of primitive art imported from Africa and the South Seas was beginning to be noticed by certain painters in Paris, and styles which had formerly been despised as barbaric began to be recognized as possessing great emotive strength.

On his return from Gosol in the autumn of 1906, Picasso had continued to emphasize and simplify form, especially in his paintings of nudes (Plate 12); but it was not until that winter that he was to start work on a large canvas which was to be a turning-point not only in his own career but also in the history of contemporary art. In the same spring he had painted *The Harvesters* (New York, Private Collection), a picture which shows more than any other a use of colour similar to that of the Fauves and also a desire to create movement in a composition. Both these tendencies were used in this case at the expense of a more penetrating sense of form. But in the great picture *Les Demoiselles d'Avignon* (Plate 15), his aim had changed. Colour was strictly limited to pinks and blues and forms became clearly defined and static. For many months he had prepared great quantities of studies and he continued his ideas in 'postscripts' long after the painting had been left unfinished. This painting became the testing-ground for doubts that had troubled him. With a courage which greatly perturbed his friends, he sacrificed all the charm, bordering at times on the sentimental, which had built up an early fame. In his search for more powerful forms of expression he had become conscious of the vitality of primitive art and his recent visit to Catalonia had renewed his desire to recapture at all costs its fundamental qualities. The result was a great picture which was greeted by cries of horror from his most enlightened friends and which, although left rolled up in his studio for more than twenty years, was nevertheless to become an overwhelming influence in the future.

The period which followed *Les Demoiselles* began with paintings which developed out of the treatment of the two figures on the right of the painting. Their similarity to African sculpture, which had that year become one of Picasso's sources of inspiration, has led to the adoption of the term 'Negro period' for the months that followed. The new style depended in particular on a simplification of form and a clarification of the methods by which it was depicted. With a disregard for classical tradition, distortions were used freely to emphasize volume and convey emotional sensation. Picasso applied his discoveries with great consistency to all the subjects that presented themselves to him: the human form, flowers, landscapes, portraits or still life.

In the summer of 1908 Picasso spent a few weeks in the country north of Paris, using his new style to paint landscapes. On his return he was surprised to find that Braque, with whom his friendship had begun a year earlier, had also independently followed a similar course

in the south of France. It was these paintings by Braque which were first given the name 'cubist' by the critic Vauxcelles when they were exhibited a few months later.

During the following summer, at Horta de San Juan, Picasso developed the principles of his new style still further. The clear-cut rocky landscape gave him the opportunity to pursue Cézanne's recommendation that nature should be considered in terms of the cylinder, the sphere and the cone, a principle which he applied with equally astonishing results to portraits and to still life (Fig. 4).

1910-12: Analytical Cubism

'I paint objects as I think them, not as I see them.' This remark made by Picasso to the poet Ramon Gomez de la Serna explains the essential divergence between Picasso and Cézanne. The latter had drawn his inspiration primarily from his immediate visual reaction to the objects before him. Picasso was increasingly drawn to making creations according to his own internal vision. In African art he had found a conceptual art which, in the same way, was not based on immediate visual reactions to a model. The original impact had been violent. It had forged the first real link between African art and Western ideas and it was followed during the two years that succeeded the painting of *Les Demoiselles d'Avignon* by a growing tendency to bring order into these first impulses.

In close association with Braque, 'roped together like mountaineers', as Braque expressed it, Picasso began to clarify and systematize a new conception of the painter's experience. In order to understand form and interpret its existence on a flat surface they felt it necessary to break into the form, separate its elements, penetrate beneath the surface and become conscious of that which cannot be seen because accidentally it is at the back of the object in question. The appearance of an object taken from one point of view was manifestly insufficient. It should be conceived from all angles (Plates 20, 21). They painted what they knew to be there. To do this effectively certain limitations seemed desirable. For a time both Braque and Picasso severely limited their palettes to sepia and grey with the occasional intrusion of an olive-green or ochre. Secondly, the traditional rules of linear perspective were completely abandoned, and modelling in the round gave place to flat crystalline facets which, built up together, gave the appearance of solid form (Fig. 5; Plates 19, 20, 21). The system depended also on a close relationship between the figures or objects and their background. A sense of homogeneity throughout the picture was created by uniting the background closely with the objects so as never to allow a rift to appear between them. Each facet overlaps or touches its neighbour, giving an appearance both of a solid architectural construction and of the translucence of crystal. The fervour with which the two creators of cubism developed their discoveries led them into a language of abstractions. Their work became more purely conceptual and increasingly detached from normal visual appearances (e.g. Plate 21). For a while they preferred not even to sign their works, so as to give them a sense of detachment, even impersonality; as a result it is sometimes not easy to distinguish between their work at this period.

It would be a mistake, however, to see in these works purely impersonal abstract design. In every case they are based on the conception of some definite object, as well as the personality of the artist. Clues are always to be found. A symbolic moustache gives the clue to the face in which it may be the only recognizable feature. The curve of a guitar or the stem of a glass is a guide to the identity of objects

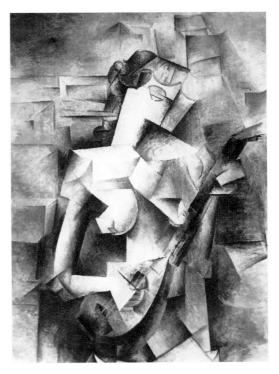

Fig. 5
Girl with a Mandolin
(Fanny Tellier)
1910. Oil on canvas,
100.3 x 73.6 cm.
The Museum of Modern
Art, New York.

13

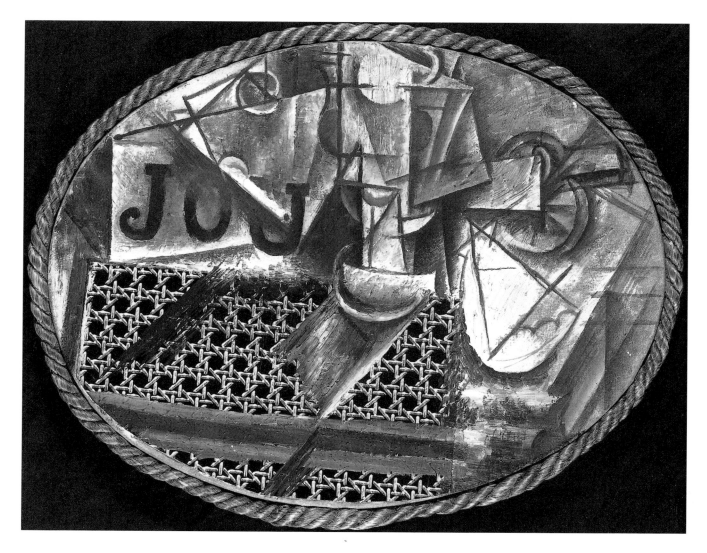

Fig. 6
Still Life with Chair
Caning
1912. Collage of oil,
oilcloth, and pasted paper
on oval canvas, rope
surround, 27 x 35 cm.
Musée Picasso, Paris.

that have been shattered and rebuilt as an integral part of the picture. The eye as it travels over the picture finds itself above, behind and in front of the object at the same time, but the movement is in the consciousness of the spectator rather than in the object itself. All these varied aspects are woven together into a new realization of the totality of the object.

1912 - 16: Synthetic Cubism

In their enthusiasm during the first heroic years of cubism, Picasso and Braque carried this style, which had metaphysical as well as visual significance, to a degree of purity which threatened to make it a completely hermetic art. By the autumn of 1911 their analysis of form had led them to a point where all signs of the presence of the object itself had become difficult to trace. It became necessary to form a new link between painting and reality. Picasso had on several occasions demonstrated his love for his new companion, Eva (Marcelle Humbert), by introducing the letters of her name or the inscription *J'aime Eva* into his paintings, as a lover might carve initials in the bark of a tree. This addition, which might seem irrelevant, brought a new reference to reality into work otherwise verging on abstraction. Braque also had felt the same need. Having been trained by his father, a *peintre-décorateur*, in the techniques of painting *trompe l'oeil* surfaces of marble and grained wood, he now introduced these into his work. Short-cutting Braque's painted imitations Picasso carried the idea further by taking a piece of oilcloth

on which a pattern of chair-caning had been realistically reproduced, and sticking it to the canvas itself.

From this followed rapidly the use of newspaper, wallpaper or any other ready-made material which could serve the dual purpose of becoming part of the composition and adding its own reality to the picture. This addition of foreign materials applied to the canvas itself was a revolutionary step, breaking the tradition established since the Renaissance, when painters abandoned the medieval embellishments in gilt relief and insisted on a unity of material throughout the picture.

The new technique (*papier collé*) proved to be an important discovery. It enabled Picasso to work with great rapidity, sometimes pinning scraps of coloured or patterned paper on to his work and varying their positions as he desired. In the *Still Life with Chair Caning* (Fig. 6; the work, produced in Paris, still belongs to the artist), the first painting in which Picasso used this new technique, the letters JOU, part of the word '*Journal*', are painted next to a glass which has all the characteristics of the earlier analytical devices of cubism. Both of them are situated close to the piece of oilcloth which simulates chair caning; thus they have various meanings and create varying degrees of deception, a device which has been described as a visual pun. The austerity of hermetic abstractions had given way to a light-hearted self-criticism.

Another development was the return to colour, or rather coloured surfaces, which could, by their action on the eye, give a sensation of depth. The former system of gradations in tone which created crystalline facets tended to give way to simple flat or textured planes. Texture, it was found, could also be used to differentiate between areas: it could put them on different planes and had the effect of a new method of perspective. The textures were in some cases created with sand, and in others simulated a 'pointillist' technique. By 1913 the monochromatic effects of early cubism had been abandoned; colour assumed a new role: it glowed from flat, evenly coloured and clearly defined areas and had no relationship to the Impressionist use of colour to create atmosphere.

A cubist painting was becoming an object in its own right; a tendency which brought Picasso to experiment in the creation of bas-relief constructions which were halfway between painting and sculpture.

During the early years of cubism, Picasso had devoted himself entirely to discoveries which led towards abstraction, but already in 1915 he began again to make drawings and some paintings in which he showed once more his extraordinary talent for conventional representation. Drawings of his friends, Max Jacob, Vollard, and Apollinaire, made during the war, have the assurance and purity of line of drawings by Ingres.

1917-24: Cubism and Classicism

During the years of the war Picasso suffered not only from the dispersal of his friends but also from the death of Eva in the winter of 1915-16. Although he never ceased to paint and to develop the discoveries of cubism, his production during these years was less prolific. In the spring of 1917 he was persuaded by Jean Cocteau to go with him to Rome and design scenery and costumes for the ballet *Parade*, which was to be presented in Paris that summer (Fig. 7). This expedition brought Picasso into contact with a new milieu and his visit to Italy revived his delight in classical forms and awakened a new interest in the *commedia dell'arte*. It was here that he met the young ballerina

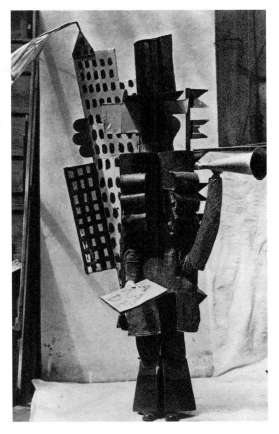

Fig. 7
Manager from
New York
Costume for 'Parade',
1917.

Fig. 8
Two Bathers
1920. Pastel, 108.5 x 75.8
cm. Musée Picasso, Paris.

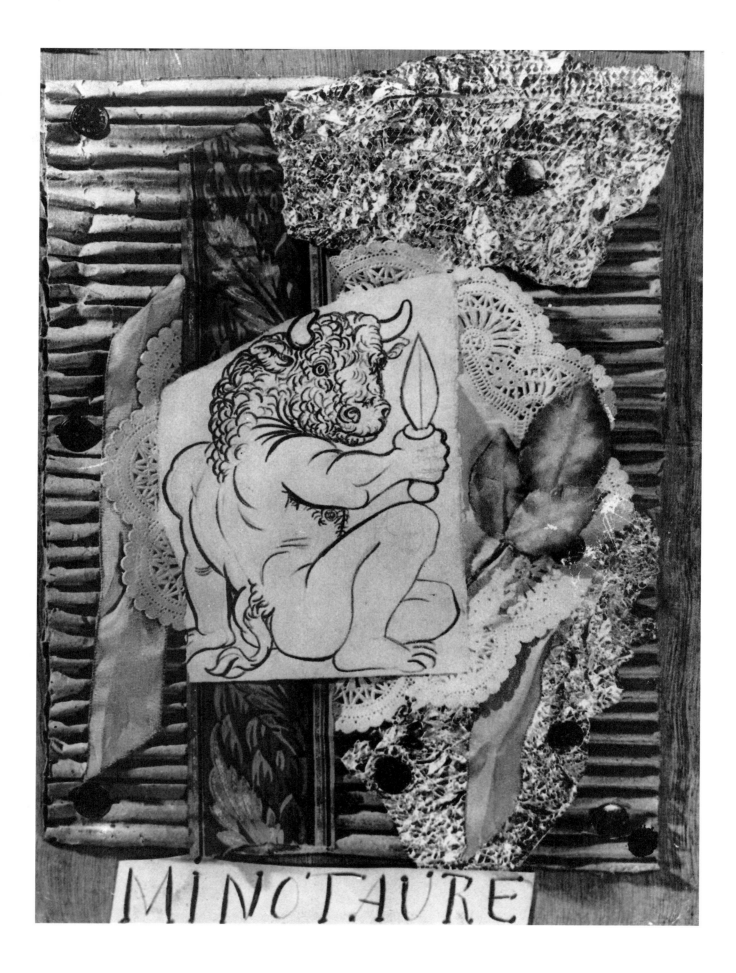

Olga Koklova, whom he married in the following year.

On his return to Paris his work showed frequent references to classical subjects (Fig. 8), and the portraits of his beautiful young wife again show his consummate skill in representational painting. However, the achievements of cubism were never abandoned and he continued to develop this style with increasing strength. It culminated in two great canvases, variations on the same subject, *Three Musicians*, painted in 1921 (Plate 28). The other version is in the Museum of Modern Art, New York. As a parallel to the cubist paintings, Picasso made many paintings of female figures, nude or with classical drapery. He emphasized the fullness of their forms, endowing them with a sense of fertility and motherhood. Whatever dimensions he used for the actual size of the canvas, these figures always suggest monumental proportions.

In 1921 Olga gave birth to a son and Picasso's work reflected at once his preoccupation with this event. Motherhood became a dominant theme in his painting in the neo-classical style.

With the renewed possibility of travelling during the summer months after the war, Picasso paid visits to the Mediterranean. During these years a subject which was repeated with many variations was a table laden with objects standing before an open window. Familiar objects such as the guitar, the bowl of fruit and wine bottles continued to be the chief elements in a series of still life paintings. After passing through a variety of moods, Picasso arrived at some of his major triumphs in the great canvases of 1924 and 1925. In these the techniques of cubism are used in a masterly way; the objects and their shadows interlock in great harmonious compositions, brilliant in colour and poetic invention.

1925-1935: The Anatomy of Dreams

The strong influence of classicism on Picasso revealed itself not only in classical figures and compositions but also in the order and purity of form which he had imposed on the great cubist paintings, mostly still life, up to 1925. In this year, however, a new torment that had begun to disturb his spirit revealed itself in a great canvas, *The Three Dancers*, 1925 (Plate 32). Here it is evident that the post-war hopes of a new Golden Age shared by so many had vanished, and yielded to a desperate ecstatic violence, expressive of frustrations and foreboding. This painting is the first to show violent distortions which have no link with the classical serenity of the preceding years. It heralds a new freedom of expression. During the following years the human form was to be torn apart, not with the careful dissection practised during the years of analytical cubism, but with a violence which has rarely been paralleled in the work of any artist. Picasso, however, not only decomposes and destroys, he invents new anatomies, new architectures and a new synthesis, incorporating the world of dreams with mundane reality (Plates 33, 34). By this means he is able to bring about a metamorphosis, more powerful and more profound than the simple *trompe l'oeil* effects produced with oil paint on canvas. The most unorthodox, and even the meanest of materials can be given a new life and a new significance by him and it is in this feat that Picasso has continually shown his poetic strength. With materials as uninviting as nails, wire, paper and a floorcloth, he has created a picture which can have a violent emotional effect.

Picasso readily understood the desire of his surrealist friends to look for inspiration in the workings of the subconscious, and he allowed his paintings to be shown with theirs in group exhibitions.

Fig. 9
Minotaure
1933. Drawing and collage. Reproduced on the cover of *Minotaure* 1, 1933.

His conviction that painting should be conceptual rather than purely visual had always led him to value the friendship of poets, and the close link in surrealism between poetry and painting appealed to him strongly. His early association with André Breton and his long friendship with Paul Eluard gave birth to a period fertile in inventions (Fig. 9).

Never in the work of Picasso do we find that the expression of emotion overwhelms formal considerations. Never does it become uncontrolled expressionism. His remodelling of the human form is based on cubist discoveries: for instance, the placing of two eyes surprisingly in a face seen in profile, a familiar characteristic from 1935 onwards, springs clearly not only from emotional promptings but also from the cubist intention to see that which is hidden but is known to exist (Plate 38). Nor has he ever abandoned his desire to interpret three-dimensional solidity of form. His methods of doing so vary, however, from the use of flat surfaces and tenuous lines to conventional shading to indicate volume. In the late 'twenties Picasso returned to bas-relief and sculpture, often inventing forms which were interchangeable in either medium. The head on the right in the painting *The Painter and his Model*, 1928 (New York, Sidney Janis) was also made up by Picasso as a painted metal construction, and this process of producing the effects he desired alternatively in either medium has increased in more recent work. In 1932, with the space afforded by large out-buildings at his recently acquired Château de Boisgeloup, Picasso was able to produce a series of important sculptures. Some were made in iron with the technical aid of the sculptor Gonzalez; others were large plaster heads inspired by a new model, Marie-Thérèse Walter, who appears frequently in paintings of this

Fig. 10
Minotauromachy
1935. Etching and scraper,
49.8 x 69.3 cm. Musée
Picasso, Paris.

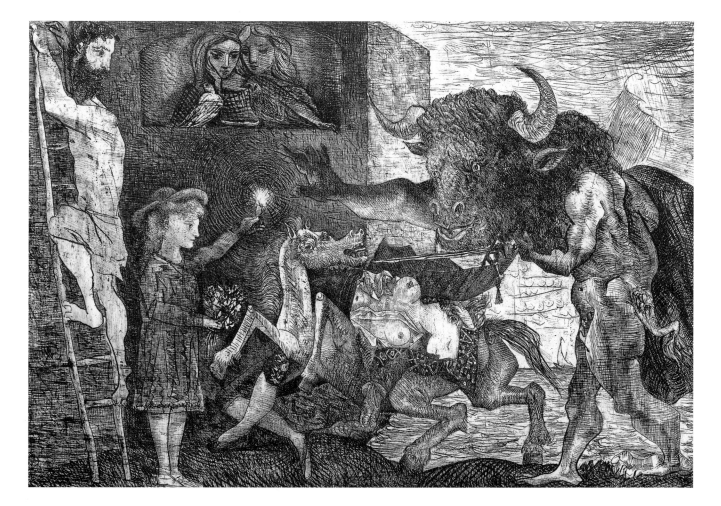

period. In 1935, Marie-Thérèse bore Picasso a daughter, Maïa.

But sculpture was not the only art besides painting which occupied Picasso in the early 'thirties. It was during this period that with great vigour he produced some of his most remarkable graphic work, illustrating many books, such as the *Chef d'Oeuvre Inconnu* of Balzac and Ovid's *Metamorphoses*, and later (in 1937) the *Histoire Naturelle* of Buffon, as well as books by his friends the poets Tzara, Eluard and others. In addition, Picasso himself found time to write many long poems, turbulent in form and violent in imagery. This prodigious activity has been characteristic of Picasso throughout his life, even during such years as these when he was undergoing the serious emotional stress which culminated in his separation from his wife.

1936-1945: Picasso Furioso

An understanding of classical mythology combined with a hereditary passion for the bullfight had led Picasso to meditate on the strange personality of the Minotaur. In a series of etchings known as *The Sculptor's Studio*, 1933, and in some remarkable drawings of the same period, this equivocal beast is seen, sometimes amorous, sometimes ferocious and sometimes blind, penetrating human society (Fig. 10). The subconscious power of the myth and Picasso's longstanding love of allegory served him as a basis for a great new painting which he was to produce in 1937. The mural which Picasso produced for the Spanish Pavilion in the Paris Exhibition that year was inspired by his anger at the destruction of the Basque capital Guernica by the forces of General Franco. This great painting, now on loan to the Museum of Modern Art, New York, is a composition which expresses magnificently the anguish of a great human disaster and owes its power to Picasso's development through cubism to a new visual language. Although *Guernica* was painted with extraordinary speed, Picasso found time to preface the final picture with many studies, such as the *Horse's Head*, 2 May 1937 (New York, Museum of Modern Art), and the *Weeping Woman* (Fig. 11), June 1937 (Paris, Mme Dora Maar), as well as numerous drawings of great emotional power. Its echoes continued into the autumn with paintings such as *Woman and Dead Child*, September 1937 and the *Weeping Woman*, 26 October 1937. These paintings are concentrations of the anguish which pervades the great composition.

In all Picasso's work of this period there is a foreboding which sometimes rises to intensity in paintings such as *Cat Devouring a Bird*, 1939 (Plate 40), and at other times reaches a raucous note of grim humour. In the great canvas, *Night Fishing at Antibes* (Museum of Modern Art, New York), the atmosphere of war which was to break out a few days later exists already in the sinister grimaces of the fishermen and the feckless grins of the girls standing beside their bicycles. The paintings that follow are deeply marked with Picasso's emotions of anguish bordering on despair, though at times his love for Dora Maar, who had shared his life since 1936, is evident in the brilliant drawings and portraits of her, and there are signs of a similar tenderness in portraits such as those of his daughter Maïa, and of Nusch, wife of Paul Eluard.

As the war continued, and the situation around him became catastrophic, Picasso's reactions became increasingly intense. There are pictures such as *Woman Dressing her Hair*, 1940 (New York, Mrs Louise R. Smith) which seem to echo a violent resentment at the horror and stupidity of war. Apart from a few still-life paintings of great charm, the work of Picasso is full of angry dark thoughts. His studies of the human head go through violent distortions, sometimes

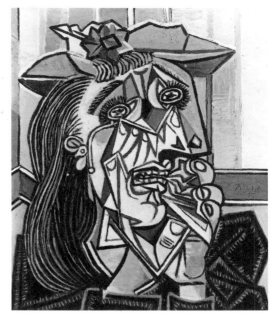

Fig. 11
Weeping Woman
1937. Oil on canvas, 54 x 44.5 cm. Tate Gallery, London. Collection Anthony Penrose.

combining the features of Dora Maar and the angular snout of his Afghan hound Kasbec, two heads in one revealing two contradictory moods.

Though materials were scarce, Picasso's wartime output was prodigious in painting and also in sculpture. It was in 1943 that he modelled, among others, a major piece, the *Man with the Sheep*, afterwards cast in bronze, in spite of the ban on using metal for sculpture.

During the comfortless winter of 1941 Picasso surprised his friends by writing in four days a short drama, entitled *Desire Caught by the Tail*. In this it can be seen that his sense of the ridiculous and his understanding of the pathetic insecurity and weakness of the human condition never left him. The still-life paintings that he produced at this time are permeated with a sense of death whose emblem appears frequently in company with a shrouded lamp or withered plants. These paintings culminated at the end of the war in another great painting, *The Charnel House* (New York, Chrysler Collection), painted in the summer of 1945, which is the epitome of Picasso's feelings concerning the horror of war and its universal consequences.

Towards to the end of the war, in a happier mood, Picasso painted several landscapes from the *quais* near his studio, of the city in which he had spent these years of misery with his friends.

1946-54: Antibes and Vallauris

As soon as the exhilaration of liberation and the return of old friends from abroad had subsided, Picasso made his way again to the Mediterranean. In the previous months spent in Paris he had worked intensively at lithographs, many of which were scenes of bullfights and still-life objects. Soon after his arrival in the south of France he was offered the vast halls of the Palais Grimaldi in Antibes as a studio, and the subject matter of his work changed abruptly. Again legendary figures predominated in his thoughts. The idyllic charm of nymphs, fauns, centaurs and satyrs, dancing and regaling themselves in Arcadian scenes, appeared in paintings and lithographs, and among them emerged a new face, radiant as the sun and delicate as a flower, that of Françoise Gilot, who had accompanied him. The work of this period is collected together in the museum at Antibes, forming a testimony to months of newly-won tranquillity.

In 1947, the year in which Françoise gave birth to their son Claude, Picasso became attracted by the possibilities offered by the potteries of Vallauris, and a year later he moved there with his new family. This began a period of great creative production in ceramics, an art which he treated in a similar way to polychrome sculpture. At the same time he continued to paint with great vigour. Portraits of Françoise, his son Claude and his daughter Paloma, born in 1949, are usually brilliant in colour and decorated with vigorous flourishes and arabesques. The paintings of his children at play, reading or lying in bed asleep show tender observation of their behaviour. Unlike the paintings of the Blue Period, they are devoid of all sentimentality and reveal the complex joys and passions of childhood. The Mediterranean landscape around him was also an enchantment to Picasso both by night and by day, and remained always closely associated with his proverbial love of the sea.

The presence of Picasso brought new prosperity to Vallauris and was greatly appreciated by the inhabitants. The life-size bronze *Man with the Sheep* was set up in the main square, and Picasso was invited to decorate a small and beautiful medieval chapel which had fallen into disuse. To cover the vault of the nave of the chapel, he painted in 1952 two large panels which displayed allegories of war

on one side and of peace on the other.

There is an abundance of variety in the styles used by Picasso during these years, varying from the almost abstract composition of the *Goat's Skull, Bottle and Candle* (Plate 44) to the fantasy and playfulness of the *Sport of Pages*, 1951 (collection of the artist). This latter corresponds more closely in style to the great paintings of *War and Peace*, although in these the symbolic figures are treated with less detail and the overall appearance is one of grave simplicity.

1955-61: Cannes and Vauvenargues

On 13 December 1954 Picasso began work on a series of fifteen variations on Delacroix's painting *The Women of Algiers* (Plate 46), which he finished on 15 February 1955. This was not the first time that he had taken the theme of a painting which he admired and without any intention of copying the original, used it as a basis for variations on the composition in his own terms. Previous examples came from very varied sources: Le Nain in 1917, Renoir in 1919, Poussin in 1944, Cranach in 1947-9 (Mourlot, *Picasso Lithographe*, Paris, vol.II, 1950, 109 and 109 bis), Courbet and El Greco in 1950 (Plate 44) and more recently Velazquez, *Las Meninas* (*The Ladies in Waiting*). There are two versions of the Delacroix *The Women of Algiers*: one in the Louvre and the other in the Musée Fabre at Montpellier, but Picasso states that he had not seen either of them for many years. His visual memory allowed him, however, to work on the variations even without the aid of a reproduction. In quick succession he painted a number of variations, some in monochrome and others with brilliant colour, interpreting the composition and the anatomy of the women with his usual boldness. The same trend, beginning with more representational studies and arriving at nearly abstract conceptions in the latest work, can be found in the series of *Las Meninas*, painted three years later.

After his rupture with Françoise Gilot in 1953, Picasso found a new and devoted companion in Jacqueline Roque. His love for her is evident in portraits painted in June 1954. With her he installed himself in the villa La Californie, overlooking the sea near Cannes. Although the architecture of this house is in no way pleasing it afforded him ample space for his work and its interior, often with Jacqueline seated among his canvases and sculpture, became the theme for many important paintings. The diversity of his activities, with ample working space at Cannes and Vallauris still within reach, became even greater; painting, sculpture, ceramics, engraving and lithography occupied the greater part of his time. In addition, in the summer of 1953 he became the sole star performer in a film produced by Georges Clouzot entitled *Le Mystère Picasso*.

In the paintings of these years echoes of the many experiences through which he had lived can be found, as well as the perennial, underlying influence of cubism. His mastery of so many styles enabled him to work with great assurance, freedom and speed. Painting became more than ever linked with sculpture. Bronzes often inspired by the metamorphosis he could create by the assemblage of surprisingly dissimilar objects came to life in the same playful way in which his early 'collages' had been produced. In many cases the metal was painted, producing a unity between painting and sculpture. Intuitively he was continuously inventing unconventional techniques to produce new effects. Whatever means tempted him would be given a trial, such as the use of feathers from his pigeons picked up from the floor instead of brushes, an idea which produced *L'Arlésienne* of 1958.

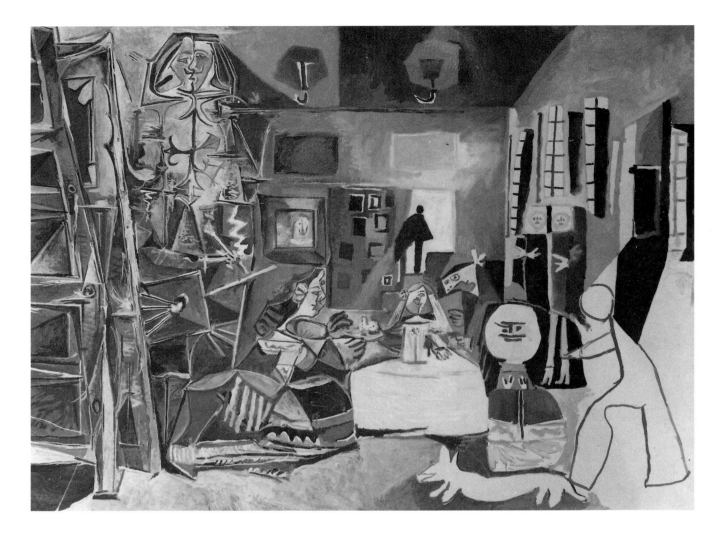

Fig. 12
Las Meninas
1957. Oil on canvas,
194 x 260 cm.
Museo Picasso, Barcelona.

In the autumn of 1957 Picasso embarked on a period of exceptional concentration, shutting himself off from his friends for more than two months. During this time he painted a series of variations on *Las Meninas* of Velazquez, a painting that had fascinated Picasso when he first visited Madrid with his father at the age of fourteen. Working rapidly on a great number of canvases of all sizes he vigorously transformed Velazquez's handling of this strangely ambiguous version of the old theme, the artist and his model. He respected the principal elements of this dramatic composition, the lighting, the spacing of the figures, their gestures, and even the texture of their dresses, but he became ruthless in the transformations he brought about (Fig. 12). At the same time, as a foil to Velazquez's sombre version of the interior of the Spanish court, inherited from the past, he also became preoccupied with a scene that presented itself daily, framed by the studio window from which his pigeons launched themselves into the radiant atmosphere of the Mediterranean. The complete series was presented by Picasso five years later to the new museum dedicated to him in Barcelona.

Other major works soon began to occupy Picasso's attention, in particular the great mural which he painted in Cannes for the new Unesco building in Paris. The first photographs of the painting, published in the press, met with severe criticism and when it was shown in the playground of a school in Vallauris, several critics expressed their disappointment. Once the panels on which it had been painted were set in place in Paris it became apparent, however, that Picasso had compensated brilliantly for the difficulties imposed by the archi-

tecture of the hall, although he had been given no more than a small model to work from. It is impossible to see the whole composition except from very close quarters, but the theme, with allegorical overtones that suggested *The Fall of Icarus* as an appropriate title, unfolds itself dramatically to the spectator as he moves towards it and as the whole painting gradually comes into view. The subtle way in which this gigantic mural enhances its surroundings and works with them without Picasso having been able to see it in place is a further proof of his intuitive understanding of visual problems.

The increased popularity of bullfighting in France since the war and its inevitable association with Spain reawakened Picasso's enthusiasm for the arena. His 75th birthday was celebrated at Vallauris by a mock bullfight and in the same year he completed a splendid series of drawings and engravings made after his visits to the more traditional *corridas* that took place in the Roman arenas of Provence. On his return from one of these events in Arles, in the autumn of 1958, he stopped at the Château de Vauvenargues which was then for sale and a few days later he became its owner. This ancient château is situated at the foot of the Mont Ste.Victoire, made famous by the landscapes of Cézanne. For a few years, he escaped at times during the summer to its seclusion and produced paintings in which the colours of water, meadows, dark pines and the brilliant whiteness of limestone rocks form the background for the gaily dressed figures. It was in this atmosphere that Picasso embarked on another series of variations inspired this time by Manet's *Déjeuner sur l'Herbe* (Paris, Musée d'Orsay), introducing into them the deep shadows and brilliant verdure that surrounded him at Vauvenargues, and obtaining atmospheric effects that would have been the envy of the Impressionists.

It was not long before Picasso found out that the comfort of a large modernized Provençal house near Mougins, which has the appropriate name of 'Mas Notre Dame de Vie', suited him better than the wild beauty of Vauvenargues or the villa La Californie, which was rapidly being encroached on by tall blocks of apartments. Moving there in 1961, he enlarged it with new studios and lived there in seclusion, rarely moving out into the real world. He surrounded himself with all the facilities necessary for his work which occupies him daily and often late into the night. In addition, his needs are continuously and zealously satisfied by his wife Jacqueline, whom he married in 1961.

Notre Dame de Vie

The change of dwelling did not interrupt the main flow of Picasso's work. The *Déjeuner sur l'Herbe* series led to new interpretations of that recurring theme, the artist and his model (Plate 48). Former discoveries blossomed forth again with great variety and unprecedented freedom in the manipulation of paint and reconstructions of the human body. The theme allowed him to express with endless variety his insatiable interest in the female form seen often as an integral part of the landscape. It was accompanied in 1963 by canvases varying in size from two metres high to small compositions of the subject *The Rape of the Sabines* (Fig. 13), which introduced again an element of violence without the anguish of *Guernica*.

As usual, intensive periods of painting were interspersed with other methods of expression. With his usual ingenuity Picasso revolutionized the somewhat banal technique of the lino cut and produced by new methods a great quantity of large prints in colour, the subject varying from still lifes of fruit at night under the blaze of a naked electric lamp to idyllic scenes of fauns, bulls and centaurs. Also there

were smaller, imaginary lino cut portraits of elegant courtiers and ladies of the sixteenth century. The grandee had frequently appeared in the past with sword, wig, cloak and ruff, often as a mockery of pompous Spanish traditions, but at other times he is more closely related to Rembrandt and has a more bucolic appearance. It is this character who seems to form a link between the aristocracy of the past, with its mixture of refinement, arrogance or egotistical stupidity, and Picasso's intimate feelings about himself – now that his genius is so universally acclaimed – feelings haunted by that inner doubt about his own achievements that still follows him as his shadow.

This was borne out in the great exhibition at Avignon in the Palais des Papes when 165 canvases and 46 drawings which were all produced in one year, 1969, were shown. The *hidalgo* in full regalia including pipe and broad brimmed hat dominated, sometimes having the austerity of Zurbarán's monks and elsewhere the appearance of the most debauched courtier of Frans Hals.

During the early years of the 1960s, Picasso devoted much of his time to sculpture. The process he had developed in his early cubist period of making figures out of bent sheets of cardboard and which he completed with paint, was used again to build maquettes for sculptures which under his supervision were consolidated in sheet iron. Many of these are portraits of Jacqueline, in which empty space comes to life between the folded surfaces of the painted metal. As a direct development of this technique there emerged the monumental sculpture in iron in the Civic Center of Chicago, and others (in New York, Marseille, and many other cities) in sand-blasted concrete, a process which has been of great value in reproducing in monumental form some of the sheet iron sculptures and in incising in concrete walls drawings made by Picasso for this purpose. In the majority of these works there is remarkable cohesion between sculpture, drawing and painting, and the scale in which the major figures have been executed places them among the greatest monuments of our time.

Picasso has also devoted much of his energy to engravings, varying greatly in size. In the summer of 1968 he produced with great speed a series of 347 engravings in which his imagination produced a fabulous richness of subject matter employing old themes such as the circus, bacchanalian orgies, the artist and his model, and the ubiquitous grandee, all with startling freshness. The unhesitating manner with which the figures are drawn and the invention of new techniques would make the series alone a triumph for a mature artist half Picasso's age. It is in particular the firmness of his line and the inexhaustible fertility of his imagination which still make Picasso at the age of 90 the most youthful artist alive.

The fame of Picasso is now undisputed and will long be remembered. If he wished to take advantage of the wealth he has created, and continues to create, by his own labour he might rank materially as the richest man alive, but this could not match the richness of the vital ideas and sheer enjoyment that he has distributed so abundantly and which is of a quality that can justify his saying: 'Each picture is a phial filled with my blood. That is what has gone into it.' As he becomes more isolated in the solitude of old age he becomes even more involved in his art. He demands no more than to live with simplicity, surrounded by the love and attention of his wife, with his work as an uninterrupted drama which will never reach its final conclusion and in which wonder and doubt stimulate his proverbial youthfulness.

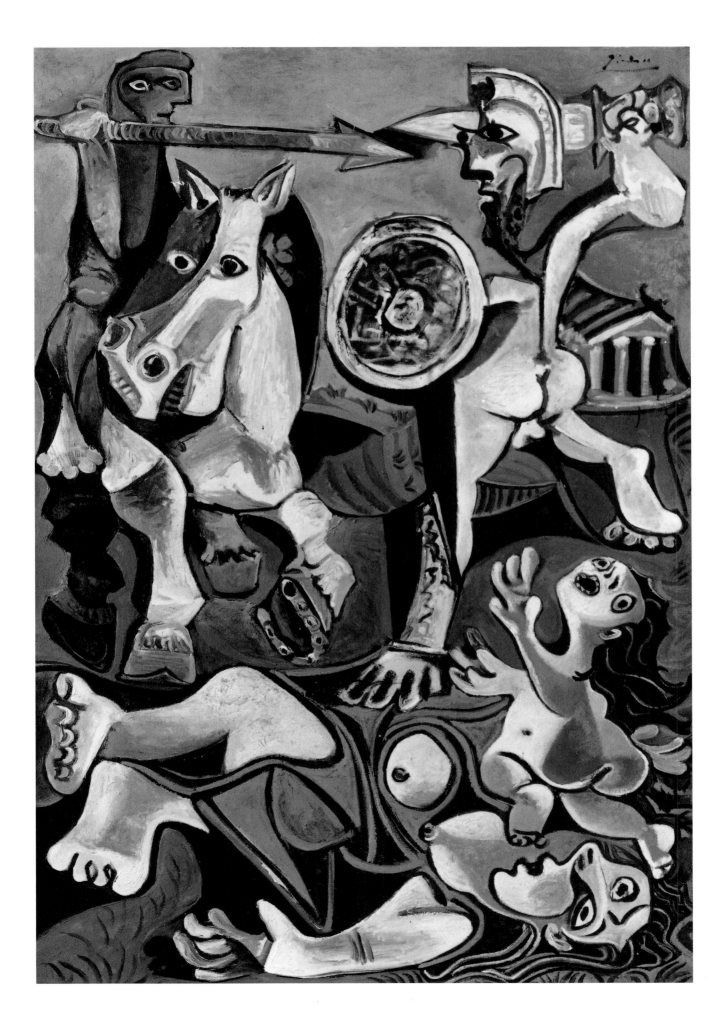

Fig. 14
Photograph of Picasso, 1904.

Outline Chronology

1881 25 October. Born Pablo Ruiz Picasso at Málaga. Son of a painter and art teacher, he showed prodigious artistic talent as a child.

1895 Moves with family to Barcelona. Admitted to School of Fine Arts.

1899 Joins the circle of artists who meet at Els Quatre Gats.

1900 First visit to Paris with Carles Casagemas.

1901 Suicide of Casagemas. Meets Max Jacob. Exhibition at Galeries Vollard, Paris. Blue Period begins.

1904 Moves into 'Bateau-Lavoir' at Montmartre. Meets Fernande Olivier, André Salmon and Guillaume Apollinaire.

1905 Attends salons of Leo and Gertrude Stein who become friends and important patrons. Rose Period.

1906 Summer in Gosol. Influence of Iberian sculpture.

1907 Paints *Les Demoiselles d'Avignon*. Meets Georges Braque, with whom he would create cubism, and the dealer Daniel-Henry Kahnweiler.

1910 Summer holiday in Cadaqués. More abstract works follow (high analytic cubism).

1912 Use of pasted papers and collage transform appearance of cubist painting (synthetic cubism).

1914 In Avignon with Braque and Derain at the outbreak of the First World War.

1917 Visits Rome with Jean Cocteau. Designs for Diaghilev's Ballets Russes including curtain for *Parade*.

1918 Marries dancer Olga Koklova.

1921 Birth of son Paulo. Major works in a classical idiom.

1925 Rapprochement with surrealism. *The Three Dancers*.

1927 Start of liaison with Marie-Thérèse Walter.

1931 Makes welded sculptures with assistance of Julio Gonzales at château de Boisgeloup.

1933 *Vollard Suite* of etchings in which the Minotaur is incorporated into a personal mythology.

1935 Temporary cessation of painting caused in part by breakdown of marriage. Starts writing surreal poetry.

1936 Supports Republican cause in Spanish Civil War. Appointed Director of the Prado. Meets photographer Dora Maar.

1937 Paints *Guernica* for Spanish Pavilion at Paris World Fair.

1941 Writes a play *Desire Caught by the Tail*.

1944 Remains in Paris during German occupation. Meets Françoise Gilot (1943). Joins Communist Party after the liberation.

1947 Alternates between Paris and the Midi. Makes ceramics at Vallauris.

1961 Marries Jacqueline Roque. Reclusive in lifestyle but work continues unabated.

1973 Dies 8 April in Mougins.

Select Bibliography

The number of books devoted all or in part to Picasso is enormous. This selection is weighted towards more recent publications in English. In addition there are several catalogues of Picasso's work from particular periods and media.

Ashton, D., *Picasso on Art: A Selection of Views*, New York 1972.

Barr, A.H., *Picasso. Fifty Years of his Art*, London 1975.

Berger, J., *The Success and Failure of Picasso*, London 1965.

Blunt, A. and Pool, P., *Picasso. The Formative Years*, London 1962.

Daix, P., *La vie de peintre de Pablo Picasso*, Paris 1977.

Gasman, L., *Mystery, Magic and Love in Picasso, 1925-1938*. Ann Arbor 1981.

Golding, J., *Cubism. A History and an Analysis 1907-1914*, London 1988 (3rd.ed.)

Leighton, P., *Re-Ordering the Universe: Picasso and Anarchism, 1897-1914*, Princeton 1989.

Lipton, E., *Picasso Criticism 1901-1939. The Making of an Artist-Hero*, New York and London 1976.

McCully, M. ed., *A Picasso Anthology*, London 1981.

Oppler, E.C., *Picasso's Guernica*, New York and London 1988.

Penrose, R., *Picasso. His Life and Work*, Berkeley and Los Angeles 1981 (3rd ed.).

Penrose, R. and Golding, J. eds., *Pablo Picasso 1881-1973*, 1973.

Rubin, W., *Picasso in the Collection of the Museum of Modern Art*, New York 1972.

Zervos, C., *Picasso*, Cahiers d'Art, Paris 1932-78.

Exhibition Catalogues

Pablo Picasso. A Retrospective, The Museum of Modern Art, New York 1980.

'Primitivism' in 20th Century Art, The Museum of Modern Art, New York 1984.

Je suis le cahier. The sketchbooks of Picasso, Royal Academy, London 1986.

Les Demoiselles d'Avignon, Musée Picasso, Paris 1988.

Late Picasso, The Tate Gallery, London 1988.

Picasso and Braque. Pioneering Cubism, The Museum of Modern Art, New York 1989.

The New Classicism: Picasso, Léger and de Chirico, The Tate Gallery, London 1990.

List of Illustrations

Colour Plates

1. Self-Portrait: 'Yo Picasso'
 1901. Oil on canvas, 74 x 60 cm. Sold Sotheby's New York, 9 May 1989.

2. Pedro Manach
 1901. Oil on canvas, 105 x 71 cm. National Gallery of Art (Chester Dale Collection), Washington D.C.

3. Vase of Flowers
 1901. Oil on canvas, 65 x 50 cm. Private collection, Switzerland.

4. Child Holding a Dove
 1901. Oil on canvas, 73 x 54 cm. National Gallery, London.

5. The Tragedy
 1903. Oil on panel, 105 x 69 cm. National Gallery of Art (Chester Dale Collection), Washington D.C.

6. La Vie
 1903. Oil on canvas, 197 x 129 cm. Cleveland Museum of Art (Gift of Hanna Fund, 1945).

7. The Old Guitarist
 1903. Oil on panel, 121.3 x 82.5 cm. Art Institute of Chicago.

8. Woman in a Chemise
 1905. Oil on canvas, 73 x 60 cm. Tate Gallery, London.

9. Family of Saltimbanques
 1905. Oil on canvas, 212.8 x 229.6 cm. National Gallery of Art (Chester Dale Collection), Washington D.C.

10. Three Dutch Girls
 1905. Gouache on paper mounted on cardboard, 77 x 67 cm. Musée National d'Art Moderne, Centre Georges Pompidou, Paris.

11. Boy With a Pipe
 1905. Oil on canvas, 100 x 81 cm. John Hay Whitney Collection, New York.

12. Nude Against a Red Background
 1906. Oil on canvas, 81 x 54 cm. Musée de l'Orangerie (Collection Jean Walter-Paul Guillaume), Paris.

13. Portrait of Gertrude Stein
 1905-06. Oil on canvas, 99.6 x 81.3 cm. The Metropolitan Museum of Art (Bequest of Gertrude Stein, 1946), New York.

14. Self-Portrait With Palette
 1906. Oil on canvas, 92 x 73 cm. Philadelphia Museum of Art (Gallatin Collection).

15. Les Demoiselles d'Avignon
 1907. Oil on canvas, 243.9 x 233.7 cm. The Museum of Modern Art, New York.

16. The Dryad
 1908. Oil on canvas, 185 x 108 cm. Hermitage Museum, Leningrad.

17. Three Women
 1907-late 1908. Oil on canvas, 200 x 178 cm. Hermitage Museum, Leningrad.

18. Nude in an Armchair (Seated Woman)
 1909. Oil on canvas, 92 x 73 cm. Private collection, France.

19. Seated Nude
 1909-10. Oil on canvas, 92 x 73 cm. Tate Gallery, London.

20. Nude
 1910. Oil on canvas, 99.1 x 78.1 cm. Albright-Knox Art Gallery, Buffalo, New York.

21. Portrait of Daniel-Henry Kahnweiler
 1910. Oil on canvas, 100.6 x 72.8 cm. Art Institute of Chicago (Gift of Mrs. Gilbert W. Chapman).

22. Violin and Grapes
 1912. Oil on canvas, 50.6 x 61 cm. The Museum of Modern Art, New York.

23. Guitar, Gas-Jet and Bottle
 1913. Oil, sand and charcoal on canvas, 68.5 x 53.5 cm. Private Collection, London.

24. Still Life With Cards, Glasses and Bottle of Rum: 'Vive la France'
 1914-15. Oil and sand on canvas, 54.2 x 65.4 cm. Mr. and Mrs. Leigh B. Block, Chicago.

25. Harlequin
 1918. Oil on canvas, 147 x 67 cm. Joseph Pulitzer Collection, St.Louis, Missouri.

26. Still Life on a Table
 1920. Oil on canvas, 165 x 110 cm. Norton Simon Museum of Art, Los Angeles.

27. The Rape
 1920. Tempera on panel, 24 x 33 cm. The Museum
 of Modern Art (Philip L. Goodwin Collection), New
 York.

28. Three Musicians
 1921. Oil on canvas, 203 x 188 cm. Museum of Art
 (Gallatin Collection), Philadelphia.

29. The Lovers
 1923. Oil on canvas, 130 x 97 cm. National Gallery of
 Art (Chester Dale Collection), Washington D.C.

30. Portrait of Olga
 1923. Oil on canvas, 101 x 82 cm. National Gallery of
 Art (Chester Dale Collection), Washington, D.C.

31. Woman with a Mandolin
 1925. Oil on canvas, 130 x 97 cm.. Formerly in the
 collection of Alexandre Paul Rosenberg

32. The Three Dancers
 1925. Oil on canvas, 215 x 143 cm. Tate Gallery,
 London.

33. Seated Bather
 1930. Oil on canvas, 164 x 130 cm. The Museum of
 Modern Art, New York.

34. Figures by the Sea (The Kiss)
 1931. Oil on canvas, 130.5 x 195.5 cm. Musée
 Picasso, Paris.

35. The Sculptor
 1931. Oil on plywood, 128.5 x 96 cm. Musée Picasso,
 Paris.

36. Nude Woman in a Red Armchair
 1932. Oil on canvas, 130 x 97 cm. Tate Gallery,
 London.

37. Woman Asleep in an Armchair (The
 Dream)
 1932. Oil on canvas, 130 x 97 cm. Collection Mr. and
 Mrs. Victor W. Ganz, New York.

38. The Muse
 1935. Oil on canvas, 130 x 165 cm. Musée National
 d'Art Moderne, Centre Georges Pompidou, Paris.

39. Weeping Woman (detail)
 1937. Oil on canvas, 54 x 44.5 cm. Tate Gallery,
 London.

40. Cat Devouring a Bird
 1939. Oil on canvas, 97 x 129 cm. Collection Mr. and
 Mrs. Victor W. Ganz, New York.

41. Woman in a Fish Hat
 1942. Oil on canvas, 100 x 81 cm. Stedelijk Museum,
 Amsterdam.

42. Pitcher, Candle and Casserole
 1945. Oil on canvas, 82 x 106 cm. Musée National
 d'Art Moderne, Centre Georges Pompidou, Paris.

43. Women on the Banks of the Seine, after
 Courbet
 1950. Oil on plywood, 100.5 x 201 cm,
 Kunstmuseum, Basel.

44. Goat's Skull, Bottle and Candle
 1952. Oil on canvas, 89 x 116 cm. Tate Gallery,
 London.

45. The Smoker
 1953. Oil on canvas, 100 x 81 cm. Sold Christie's
 New York, 10 May 1989.

46. Women of Algiers, after Delacroix
 1955. Oil on canvas, 114 x 146 cm. Collection Mr.
 and Mrs. Victor W. Ganz, New York.

47. a) Ceramic plate, decorated with a goat's
 head.
 b) Spring
 1956. Oil on canvas,130 x 195 cm. Private
 Collection, Paris.

48. The Artist and his Model
 1963. Oil on canvas, Private collection, Paris.

Text Figures

1. Guernica
 1937. Oil on canvas, 350.5 x 782.3 cm. Museo del
 Prado, Madrid.

2. Evocation (The Burial of Casagemas)
 1901. Oil on canvas, 150 x 90 cm. Musée d'Art
 Moderne de la Ville de Paris.

3. The Acrobat's Family with a Monkey.
 1905. Gouache, watercolour, pastel and India ink on
 cardboard, 104 x 75 cm. Göteborgs Kunstmuseum,
 Göteborg.

4. Still Life with Skull.
 1908. Oil on canvas, 115 x 88 cm. Hermitage
 Museum, Leningrad.

5. Girl with a Mandolin (Fanny Tellier)
 1910. Oil on canvas, 100.3 x 73.6 cm. The Museum
 of Modern Art, New York.

6. Still Life with Chair Caning
 1912. Collage of oil, oilcloth, and pasted paper on
 oval canvas, rope surround, 27 x 35 cm. Musée
 Picasso, Paris.

7. Manager from New York. Costume for 'Parade', 1917.

8. Two Bathers
 1920. Pastel, 108.5 x 75.8 cm. Musée Picasso, Paris.

9. Minotaure
 1933. Drawing and collage. Reproduced on cover of *Minotaure* 1, 1933.

10. Minotauromachy
 1935. Etching and scraper, 49.8 x 69.3 cm. Musée Picasso, Paris.

11. Weeping Woman
 1937. Oil on canvas, 54 x 44.5 cm. Tate Gallery, London. Collection Anthony Penrose.

12. Las Meninas
 1957. Oil on canvas, 194 x 260 cm. Museo Picasso, Barcelona.

13. Rape of the Sabines
 1963. Oil on canvas, 195 x 130 cm. Museum of Fine Arts (Julian Chehey Edwards Collection), Boston.

14. Photograph of Picasso. 1904.

Comparative Figures

15. The Embrace
 1903. Gouache. Formerly Galerie Thannhauser Collection, Paris.

16. The Madman
 1904. Watercolour on paper, 86 x 36 cm. Museo Picasso, Barcelona.

17. The Bath
 1905. Drypoint, 34 x 28.6 cm. The Detroit Institute of Arts.

18. Bust of a Man (Josep Fontdevila)
 1907. Charcoal on paper, 63 x 48 cm. Collection de Menil, Houston.

19. Figure with Drapery
 1907. Oil on canvas, 152 x 101 cm. Hermitage Museum, Leningrad.·

20. Study for Standing Nude (Three Women)
 1908. Watercolour and black crayon on paper, 62 x 41 cm. The Metropolitan Museum of Art, New York.

21. Woman's Head (Fernande)
 1909. Bronze, 41.3 x 24.7 x 26.6 cm. Fort Worth Art Center (Gift of Mr. and Mrs. J Lee Johnson III), Fort Worth, Texas

22. Man with a Pipe
 1912. Charcoal, 62.2 x 47 cm. Collection Dr. and Mrs. Israel Rosen, Baltimore, Maryland.

23. Guitar
 1912-13. Sheet metal, string and wire construction, 77.5 x 35 x 19.5 cm. The Museum of Modern Art, New York.

24. Man With a Hat
 1912. Pasted paper, charcoal and ink, 62.2 x 47.3 cm. The Museum of Modern Art, New York.

25. Still Life Construction
 1914. Painted wood construction with upholstery fringe, 25.4 x 45.7 x 9.2 cm. Tate Gallery, London.

26. Harlequin
 1915. Oil on canvas, 183 x 105 cm. Museum of Modern Art, New York.

27. Open Window at St.Raphael
 1919. Gouache on paper, 35 x 24.8 cm. Private collection, New York.

28. Seated Woman Drying her Foot.
 1921. Pastel, 65 x 50 cm.

29. Three Women at a Fountain
 1921. Oil on canvas, 19 x 24 cm.

30. Portrait of Stravinsky
 1917. Pencil, 27 x 20 cm. Private Collection, New York.

31. Olga with a Hat with a Feather
 1920. Pencil on charcoal outlines, 61 x 48.5 cm. Musée Picasso, Paris.

32. Four Ballet Dancers
 1925. Pen and ink, 35 x 25 cm. The Museum of Modern Art, New York.

33. An Anatomy
 1933. Pencil. Reproduced in *Minotaure* 1, 1933.

34. Girl Before a Mirror
 1932. Oil on canvas, 162.5 x 130 cm. The Museum of Modern Art, New York.

35. Goat's Skull
 1951. Pen and ink with wash, 50.5 x 66 cm. Birmingham City Museum and Art Gallery.

36. Seated Female Nude
 1956. 101 x 77 cm. Museum of Fine Arts (Intended gift Mr. and Mrs.Daniel Saidenburg), Boston.

1 Self-Portrait: 'Yo Picasso'

Oil on canvas, 74 x 60 cm. Sold Sotheby's New York, 9 May 1989.

Self-Portrait: 'Yo Picasso' was probably shown in the first Paris exhibition of work by the young Spaniard held in 1901. Already by 1899 Picasso had abandoned the academic practices of his father and joined other modern artists working in Barcelona. On arriving in Paris the following year he soon assimilated the broad array of modern art on offer there.

The vigorous paint application is clearly indebted to Van Gogh. There is also a resemblance with a self-portrait by Edvard Munch where the artist 'emerge[s] glowing with spiritual energy from a dark background'. The two artists Picasso has chosen to emulate in his *Self-Portrait* personify an heroic ideal of the creator – an image promulgated by Nietzsche who was avidly read in Barcelona.

By juxtaposing a formless mass of pigment on a palette or canvas with the virtuoso rendering of his own face, Picasso offers a measure of his talent. One already glimpses the intense gaze (*mirada feurte*) for which he would later be renowned.

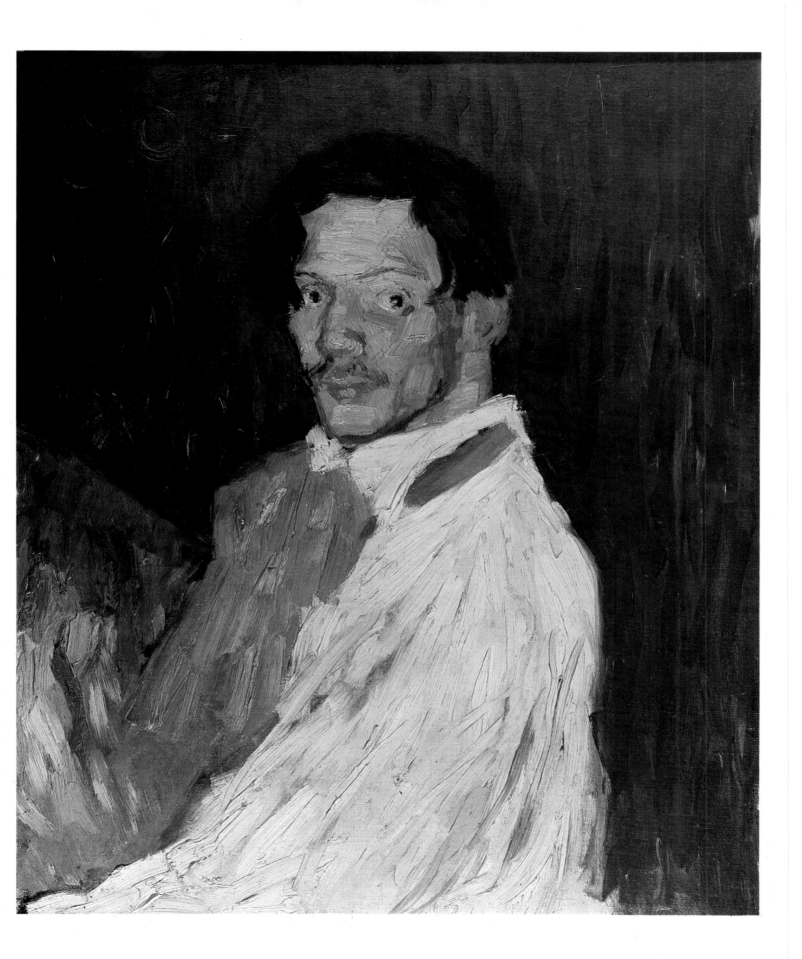

Pedro Manach

1901. Oil on canvas, 105 x 71 cm. National Gallery of Art (Chester Dale Collection), Washington, D.C.

The striking economy of means used in this very animated image is a demonstration of Picasso's claim that 'all good portraits are in some degree caricatures.' In spite of a poster-like simplicity Picasso captures the essential defining traits of his sitter. The flat areas of colour demarcated by heavy contours recall the lively portrait style of the Barcelona artist Ramon Casas.

Picasso met the dealer Pedro Manach on his first trip to Paris. Manach was the dealer of Nonell, Canals, Pitxot and Manolo – all Catalan artists who Picasso had met at the café Els Quatre Gats. Manach offered Picasso 150 francs per month in exchange for a certain number of canvases, and also put him in touch with the dealer Berthe Weill. It was Manach who mounted the first exhibition of Picasso in Paris at the Galeries Vollard. *Portrait of Manach* figured in the show (with Plate 1) and is a sympathetic portrayal of an entrepreneur and compatriot who eased his *entrée* into Parisian markets. It is the earliest of many portraits of dealers that Picasso would make over the ensuing decade. At this historical juncture private galleries were coming into their own, and art dealers were emerging as a crucial intermediary between artists and buyers.

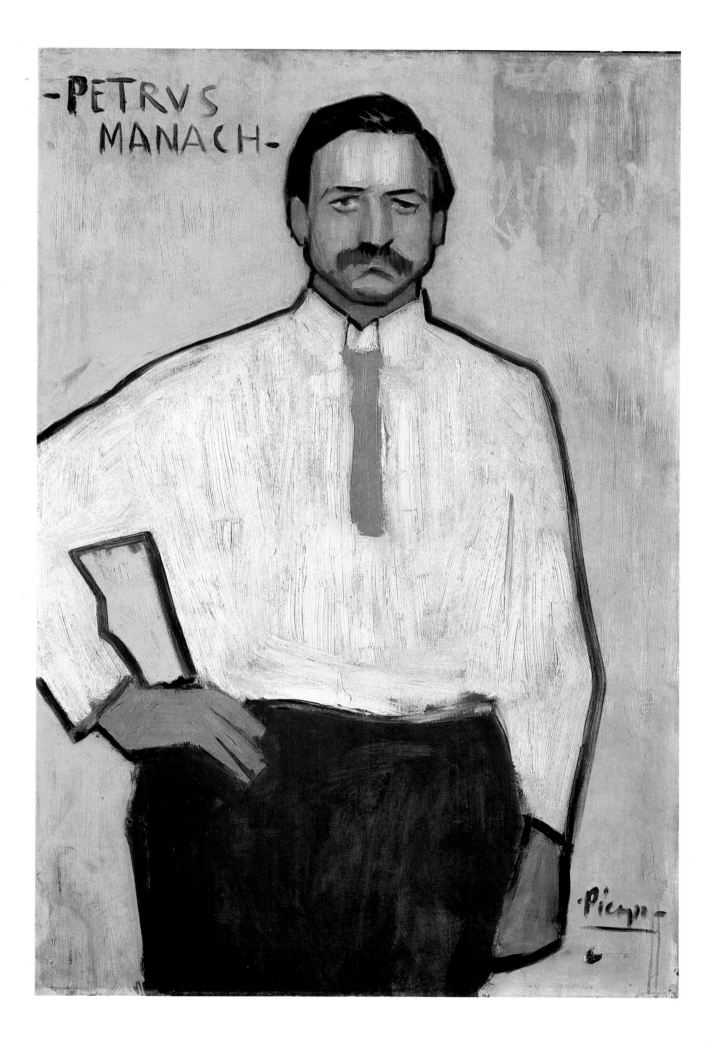

3 Vase of Flowers

1901. Oil on canvas, 65 x 50 cm. Private collection, Switzerland.

A small cluster of flower pictures reflects the eclecticism of Picasso at this point in his career. One of them, which was included in the Vollard exhibition, is a vase of irises painted in thick impasto alluding to Van Gogh. By contrast, the *Vase of Flowers* has an even pastelly texture and nuanced colours. A sprig of brightly coloured flowers to the right creates a single dramatic tonal contrast. It brings to mind flower pieces by Odilon Redon or even Gauguin. This would be in keeping with the mainly symbolist influences upon Picasso during the first years of the decade.

Flower pictures are quite rare in Picasso's oeuvre. This could be explained by the commonly held view that he was more a draughtsman than a colourist. But it might also be a hangover from his academic training since, in spite of his many formal innovations, Picasso was curiously respectful of the academic hierarchy of genres and subjects.

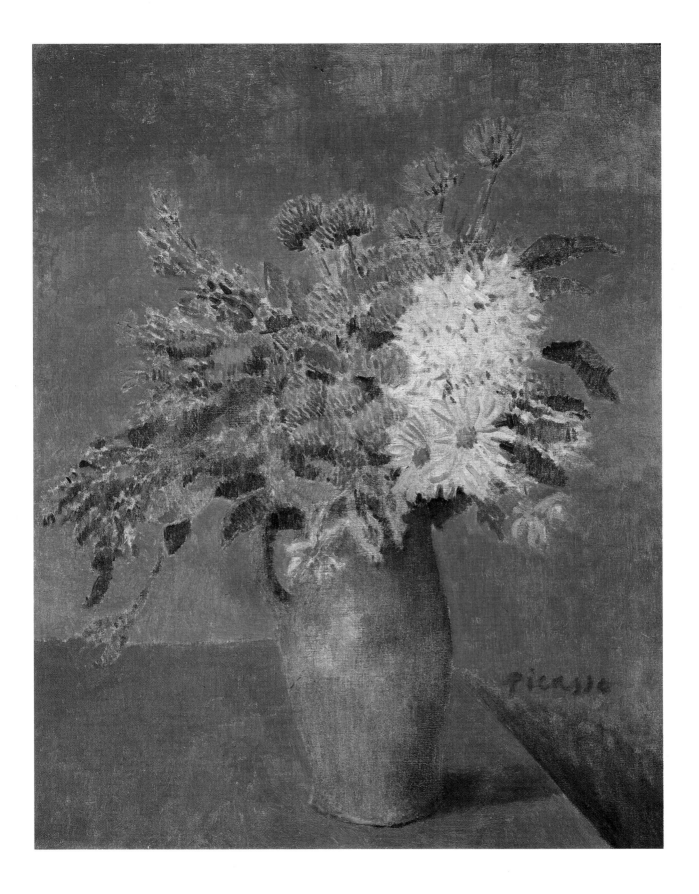

4 Child Holding a Dove

1901. Oil on canvas, 73 x 54 cm. National Gallery, London.

Picasso's father kept doves as pets and they appear among Picasso's earliest childhood drawings. It was, as was the *corrida*, a subject that constantly recurred in his art thereafter – the most famous was a lithograph which appeared on the poster for a peace conference in 1949. *Child Holding a Dove* matches in tenderness and innocent charm images of children by Renoir. The flat expanses of colour and emphatic contours are reminiscent of the *cloisonnism* of Gauguin and the Nabis painters.

The rather sombre tonalities and wistful, contemplative mood of *Child Holding a Dove* prefigure works of the Blue Period. The colour blue has many connotations within Romantic and Decadent art and literature. It was the dominant colour in the late works of Cézanne. The symbolist belief that colours could touch off specific emotions is confirmed by common language which speaks of 'the blues'. Accompanying the restriction of his palette, the varied subjects of the previous year also disappeared: flowers, cabarets and bullfights gave way to images of disconsolate outcasts.

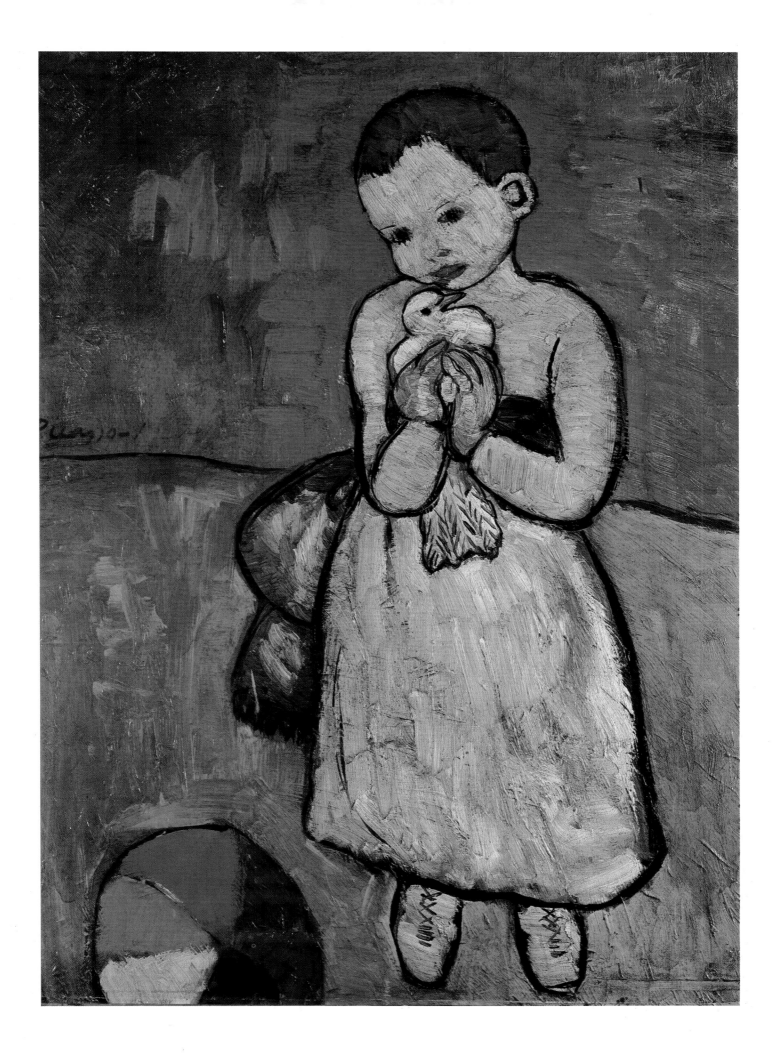

5 The Tragedy

1903. Oil on panel, 105 x 69 cm. National Gallery of Art (Chester Dale Collection), Washington, D.C.

A bearded man bowed over, a mother and a small boy stand huddled beside the sea. The nature of the tragedy referred to by the title is unexplained. All one can say is that this family group is displaced, homeless, in transit (a peculiarly twentieth-century predicament). Sources in Catalan medieval sculpture have been proposed for the attenuated and stylized figures. Puvis de Chavannes, a nineteenth-century painter whose popularity steadily grew in the first decade of this century, painted evocative vaguely mythologic compositions often situated beside the sea. His *The Fisherman* is imbued with a secular religious feeling similar to *The Tragedy*.

Isidro Nonell was a Catalan artist whose sympathetic portrayals of the poor were a major influence on Picasso during the Blue Period. How far Picasso's images of outcasts are informed by the anarchist political views of his acquaintances in Barcelona is debated. The degree of abstraction in time and place found in most of the Blue Period pictures would seem to preclude social critique, other than a general statement of alienation. Another explanation for the insistent depiction of outcasts and outsiders would be that it allowed the modern artist, who felt isolated from the values of society at large, to express his *own* marginality.

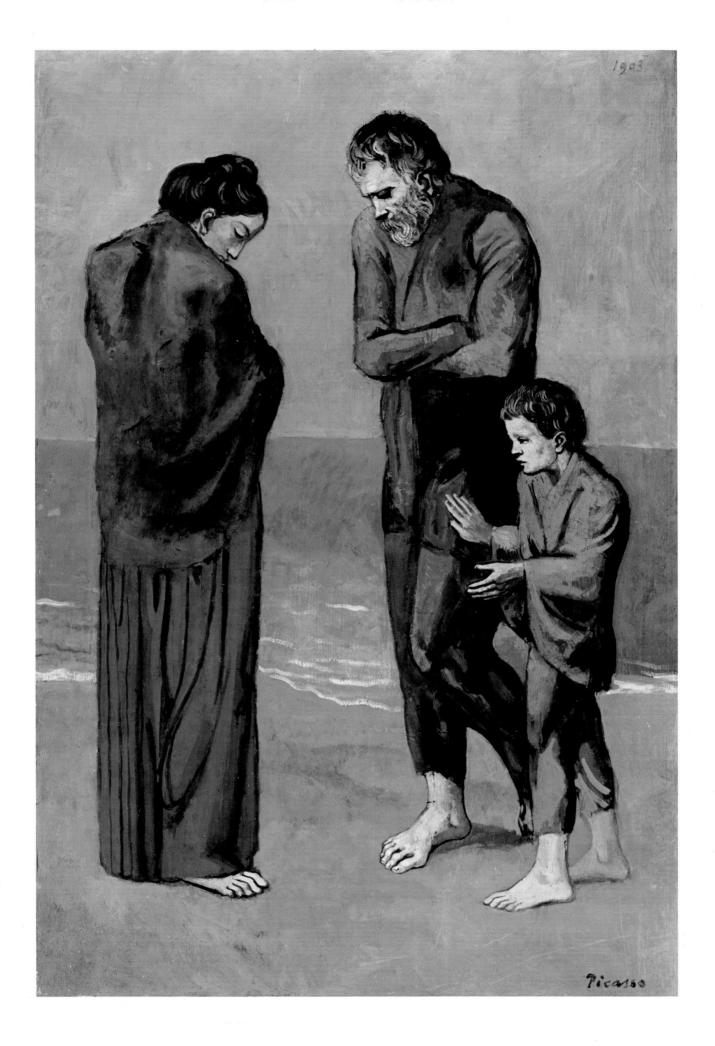

La Vie

1903. Oil on canvas, 197 x 129 cm. Cleveland Museum of Art (Gift of Hanna Fund, 1945).

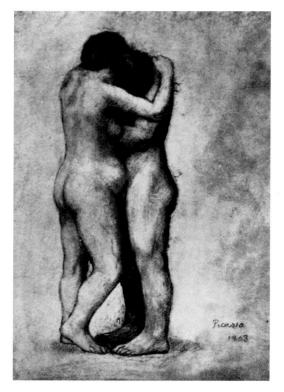

Fig. 15
The Embrace

1903. Gouache,
dimensions not known.
Formerly Galerie
Thannhauser Collection,
Paris.

La Vie turns from dominant Blue Period themes of poverty and social alienation to the problem of unhappiness in love. It refers to the suicide in 1901 of Carlos Casagemas, who had accompanied Picasso on his first trip to Paris. Casagemas was allegedly driven to despair because of impotence; his lover was a woman called Germaine, with whom it appears Picasso was later amorously involved. This real life tragedy provided the requisite raw material for a *fin-de-siècle* musing on death and sexuality. *Evocation (The Burial of Casagemas)* (Fig. 2) was painted in 1901 as a tribute. A lamentation occupies the lower part of the composition and, above, Casagemas is borne upwards on a white horse past three naked prostitutes.

Picasso returned to the subject two years later in *La Vie*. The melancholic pair, Germaine and Casagemas, huddle together on the left. He wears a loin cloth and gestures towards the gaunt and forbidding woman carrying a baby who enters from the right. Separating them are two pictures which reinforce the mood of dejection and despair. In its final state both the setting and the allegorical meaning of the composition are enigmatic. The suggestion that it contrasts sacred and profane love is disputed by Michael Leja, who shows that the mother originates from images of prostitutes drawn by Picasso at the Hôpital St. Lazare – there is no saintliness or happiness in her love. *The Embrace* (Fig.15) condenses a similar range of emotion into a monumental image of a pregnant woman and her lover.

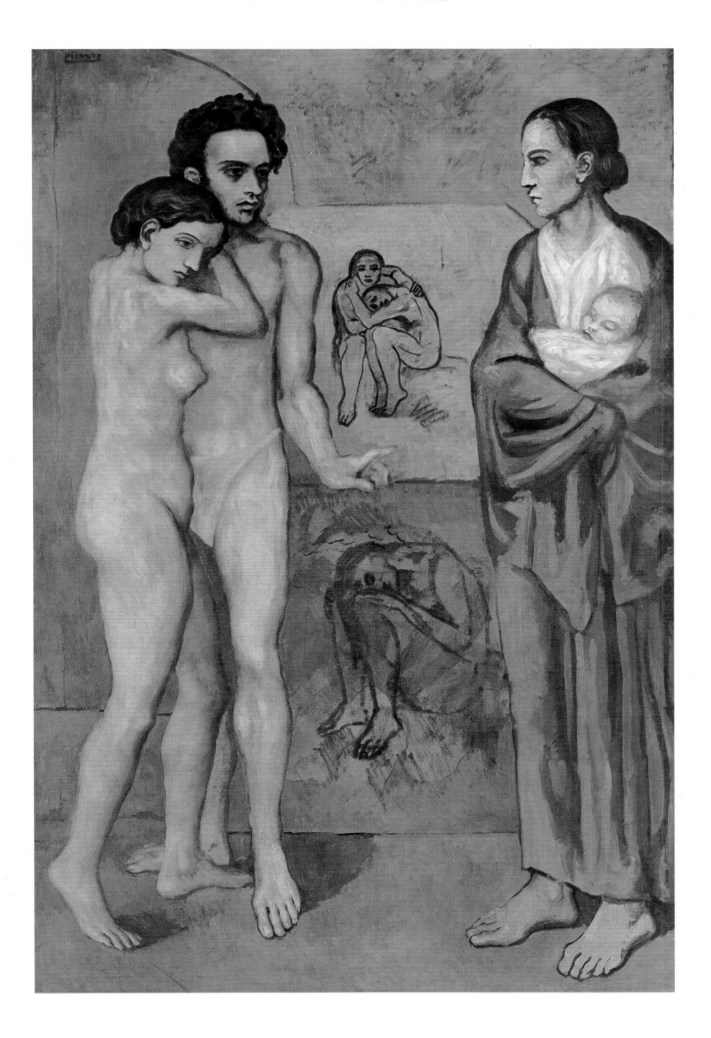

The Old Guitarist

1903. Oil on panel. 121.3 x 82.5 cm. Art Institute of Chicago.

Fig. 16
The Madman

1904. Watercolour on
paper, 86 x 36 cm. Museo
Picasso, Barcelona.

A beggar playing a guitar tune and hoping thereby to attract the charity of passersby, an urban spectacle not unfamiliar to present-day viewers, epitomizes the pathos of the Blue Period. The angular, emaciated limbs have been likened to the elongations of El Greco. Hovering in a flattened space the pose of the figure is reminiscent of the raised Lazarus. But the only salvation at hand is that which art can offer.

The blind guitarist is a surrogate for the modern artist who – like a blind man – looks inward for the source of his art. As artists retreated from society into bohemia they tried to purify their art. Music, regarded as the purest and most abstract of the arts, offered a model to which painting could aspire. This lies behind Picasso's choice of the theme. One might also speculate that the beggar sums up the dilemma of a modern artist who is alienated from bourgeois values but depends nonetheless on the bourgeoisie for charity, or patronage. *The Madman* (Fig. 16) portrays yet another misunderstood outsider with whom artists since romanticism have often identified.

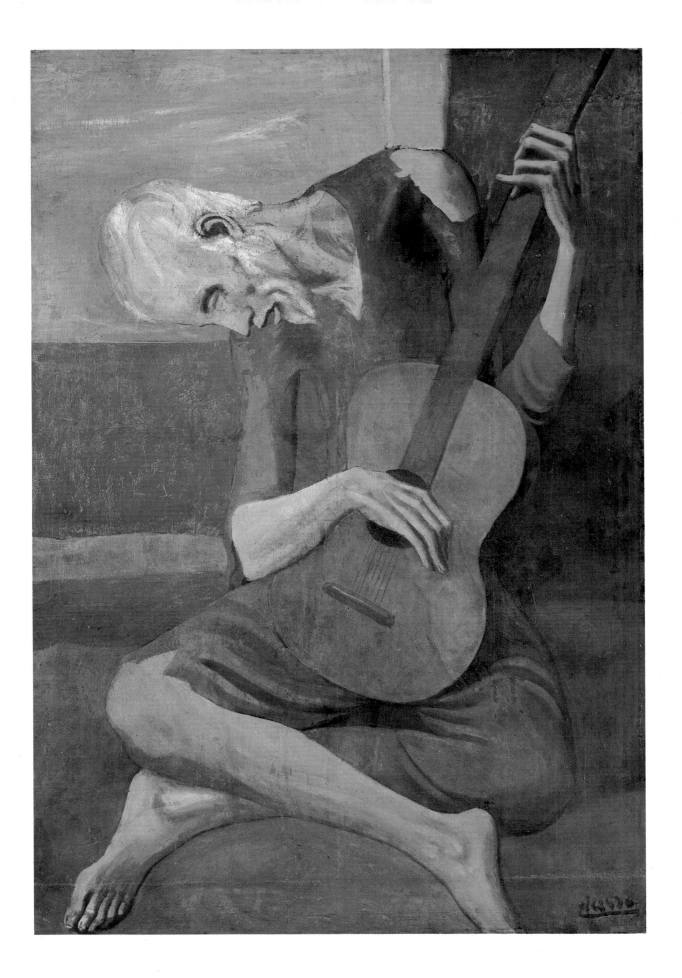

Woman in a Chemise

1905. Oil on canvas, 73 x 60 cm. Tate Gallery, London.

Fig. 17
The Bath

1905. Drypoint,
34 x 28.6 cm. The Detroit
Institute of Arts.

Woman in a Chemise is a transitional painting between the Blue and Rose Periods. Though it is stripped of anecdotal content and overt pathos, the pallor and emaciation of the young woman who stands out in ghostly silhouette against a rather desultory ground is no less poignant. Elsewhere the same model with swept up hair is shown nursing a child (see below), which may explain the emphasis given to the profiled left breast. Except for precise modelling around the face, the image seems rapidly and sketchily executed; in particular, the background is boldly brushed in (lines where the thinned paint has run can be readily distinguished).

The Acrobat's Family with a Monkey (Fig. 3) is slightly later in date. The composition recalls scenes of the Holy Family. Picasso records with exquisite delicacy a private moment in the life of circus entertainers whose company he eagerly sought out at the Cirque Médrano: Fernande Olivier writes that, 'we went there three or four times a week', and Gertrude Stein who met Picasso in 1905 adds, 'they felt very flattered because they could be intimate with the clowns, the jugglers, the horses and their riders.' Works such as *The Bath* (Fig. 17), dedicated to Apollinaire who wrote about them in the symbolist periodical *La Plume*, betoken a familiarity with and acceptance among the circus folk; his desire to be seen on a par with them is taken a step further in *Family of Saltimbanques* (Plate 9).

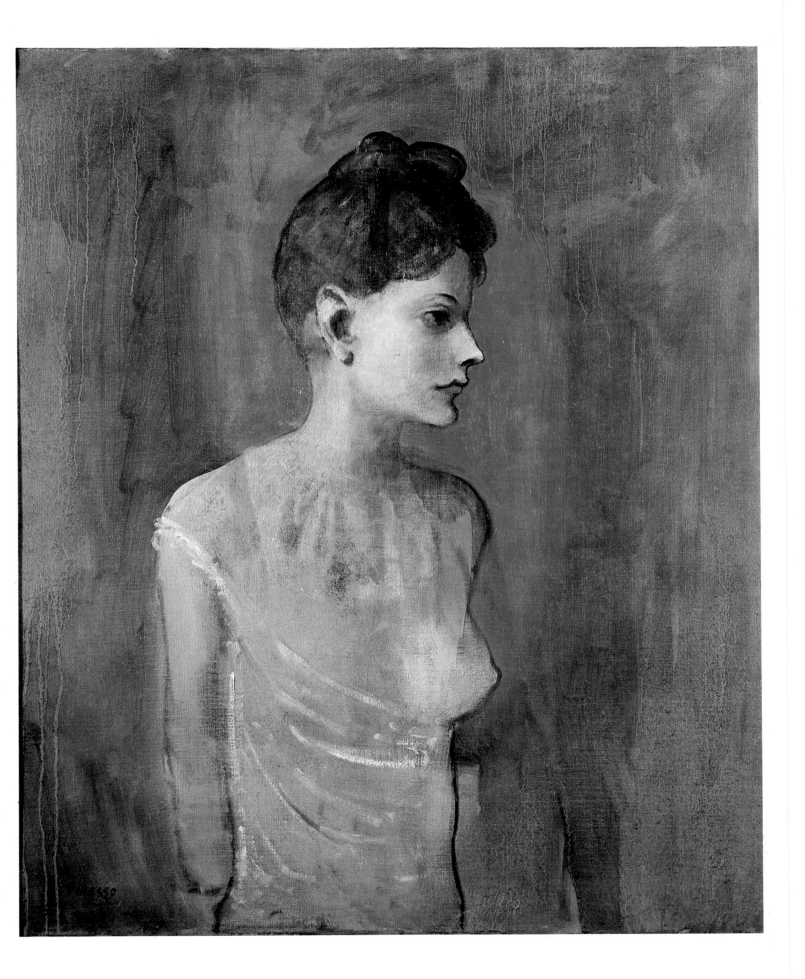

1905. Oil on canvas, 212.8 x 229.6 cm. National Gallery of Art (Chester Dale Collection), Washington, D.C.

'But tell me, who are they, these acrobats, even a little more fleeting than we ourselves...?' asked the poet Rainer Maria Rilke of the *Family of Saltimbanques*. This enigmatic composition, the largest yet painted by Picasso, culminates the short-lived Rose Period by bringing together from antecedent drawings, prints and paintings its cast of circus characters. The uprootedness of the group and the absence of any clear rapport binding them conveys what has been aptly called 'the exalted loneliness of the outsider'.

Saltimbanques were the lowest class of acrobats, who wandered from one town to another giving impromptu performances at fairgrounds; harlequin was a figure from the Commedia dell'Arte; jesters were descended from the medieval and Renaissance court. Picasso mixes all three types, as indeed happened in the circus. In reply to Rilke, it has been proposed that the saltimbanques represent *la bande à Picasso* with the artist (as harlequin in a lozenge patterned suit), his bohemian allies the poets Max Jacob (as youthful acrobat) and Guillaume Apollinaire (as a rotund jester), and his mistress Fernande Olivier whose abstracted gaze is directed off the canvas.

In the same year Picasso made explicit his self-identification with harlequin in *Au Lapin Agile*, where he appears as a disconsolate harlequin at a bar in the famous Montmartre café of that name. This alter ego returned at intervals (see Plates 25 and 28), and in the 1930s the minotaur (Fig. 11) would play a similar role.

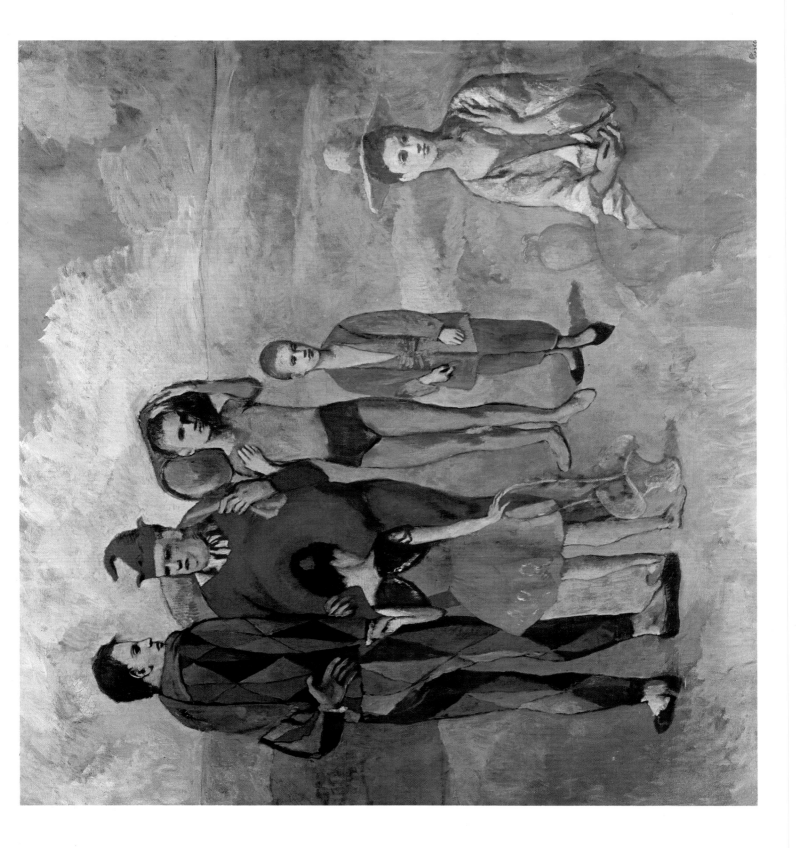

10 Three Dutch Girls

1905. Gouache on paper mounted on cardboard, 77 x 67 cm. Musée National d'Art Moderne, Centre Georges Pompidou, Paris.

Picasso departed for The Netherlands soon after completing *Family of Saltimbanques*. It is known that he was invited by a young writer, Tom Schilperpoort, and they stayed together at Schoorl, a village near Alkmaar. There is little documentation of the expedition but Pierre Daix surmises that Picasso must have been struck by 'the scale, the blondness, and pearly complexion' of the inhabitants. Certainly the model for *Dutch Girl*, the most finished picture of the visit, appears to have possessed such qualities in abundance. The solidity and rounded contours of the frontal nude hint at a shift towards the more classical forms that would dominate over the ensuing year. *Three Dutch Girls* is likewise a static and silent image; the discreet curves of the 'three graces' form a pleasing contrast with the geometry of the house and its contiguous shadow. The affectation of the Blue and Rose Period styles is supplanted by tactful restraint.

Classicism is most salient in Picasso's work of the years after 1918. In fact, however, this was his second classical phase; the first was in 1905-6 and was manifested by a preoccupation with form. This turn to classicism took place against a background of attempts by various writers to revive French Latin traditions and banish the excesses of Decadent literature, imported from England and Germany. For Picasso, a classical vocabulary of forms was ingrained from his earliest academic training and would, paradoxically, remain his native tongue.

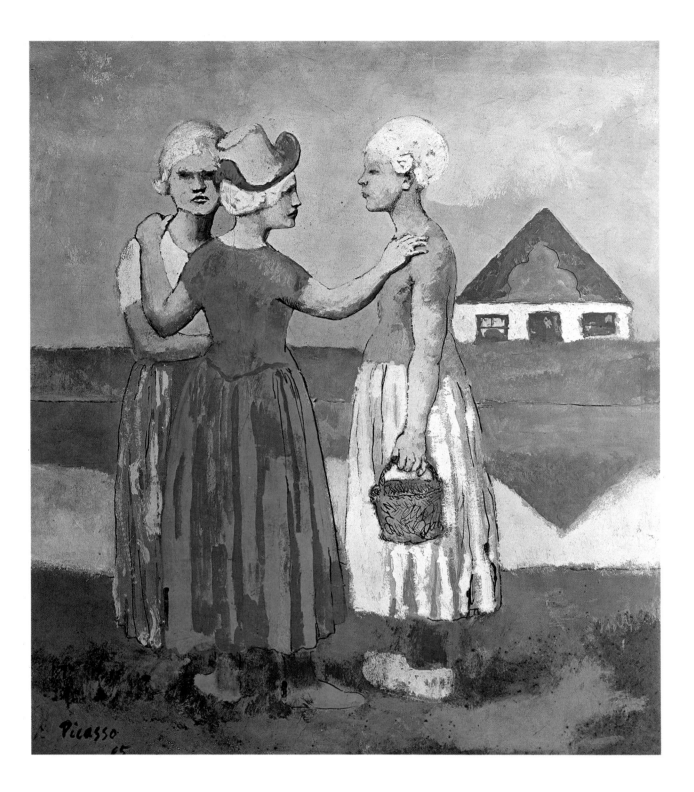

11 Boy with a Pipe

1905. Oil on canvas, 100 x 81 cm. John Hay Whitney Collection, New York.

Boy with a Pipe was painted after Picasso's return from Holland. It is a near counterpart to a picture of a young girl with a fan, whose strict profile and hieratic gesture derive from Egyptian art. This adolescent boy has a similarly grave bearing. A wan complexion and a garland round his head intimate that he is a poet – it recalls a drawing of Jaime Sabartés as a *poeta decadente* which Picasso made in 1900, although at that time the aim was satiric. Why a pipe should be held with such deliberateness is also unclear. Daix speculates intriguingly that opium may have entered the Bateau-Lavoir at this point; evidence for this is scant but clearly the image does have an other worldly air.

The model was evidently drawn from among the acrobats and circus entertainers Picasso knew. Images of jugglers and acrobats, embodying balance and repose, are plentiful at this time just as a classical impulse gained the upper hand. In later 1905 Picasso made several sketches of a naked youth on horseback to which the pose of *Boy with a Pipe* is curiously similar. Picasso's paintings of naked boys from 1905 are uniformly classical in their proportions, and are reminiscent of Greek *kouroi*.

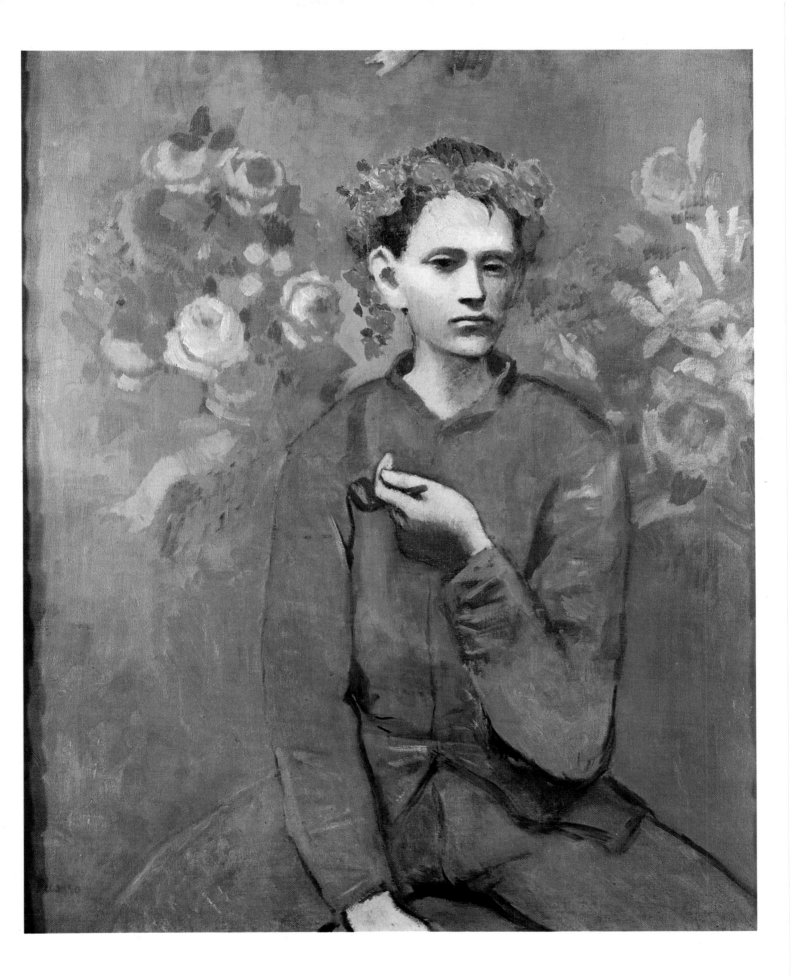

Nude against a Red Background

1906. Oil on canvas, 81 x 54 cm. Musée de l'Orangerie (Collection Jean Walter-Paul Guillaume), Paris.

A classicizing tendency led Picasso to look to sculpture as a source for his painting which in consequence became more dense and volumetric. This reaches its most extreme degree late in 1906. *Nude Against a Red Background* was painted in the summer or autumn of that year, and shows how completely Picasso had jettisoned the wispy figure types of the Rose Period. There is a striking clarity in the delineation of main volumes. Nothing distracts from the relentless focus on anatomy: the model herself seems absorbed by an awareness of her body. In conjunction with this plastic emphasis the paint facture has become more tactile (this very raw and beautiful paint surface recurs in some very late works; see Plate 45). The colour is brick red, like fired pottery.

Nude immediately precedes studies for *Les Demoiselles d'Avignon*. Already there is a quite radical departure from a classical ideal of beauty and proportion; the head is too large, the angle of the elbow is accentuated, the heavy shoulders and narrow hips are oddly masculine. This move beyond the classical coincides with the impact of Iberian sculpture that can be discerned in the facial features. Zervos correctly stated that: 'In the essential elements of this art [Iberian] he found the necessary support to transgress academic prohibitions, to exceed established measures, and to put all aesthetic laws in question.'

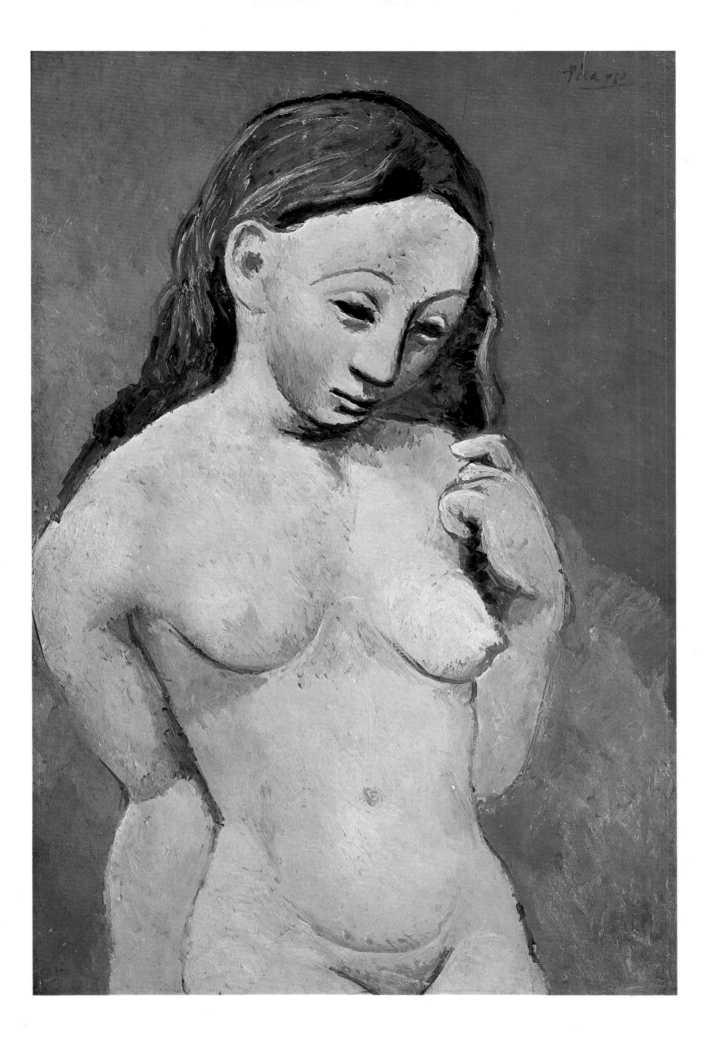

13 Portrait of Gertrude Stein

1905-06. Oil on canvas, 99.6 x 81.3 cm. The Metropolitan Museum of Art (Bequest of Gertrude Stein, 1946), New York.

The making of the famous portrait of Gertrude Stein is one of the classic fables of modern art. Stein recounts in *The Autobiography of Alice B. Toklas* how she sat eighty times for her portrait during the winter of 1906. Picasso was dissatisfied and painted out the face before leaving for Gosol, a remote village in the Pyrenees, where he remained for the summer. On his return he repainted the head before Stein had returned from her summer vacation in Italy. In the interim, several recently excavated Iberian bas-relief sculptures had been displayed in the Louvre, and the encounter with these proved decisive. Unequivocal borrowings from this pre-Roman source are evident in the shape of the head and details of the mask-like visage: 'eyelids like the rim of a cup', and a sharply incised mouth. The schematization of the face sets it apart from the rest of the picture, which is more naturalistic – this disjuncture shows how rapidly Picasso was evolving at this point.

Most observers now agree that Picasso has achieved a startling likeness of the sitter nonetheless, drawing once again upon his great skill as a caricaturist. The painting illustrates the intriguing link between caricature, with its distorting propensity, and the response to primitive art.

Gertrude Stein was well pleased with the outcome: 'He gave me the picture and I was and I still am satisfied with my portrait, for me, it is I, and it is the only reproduction of me which is always I, for me.' The mask has yielded the truth about its subject.

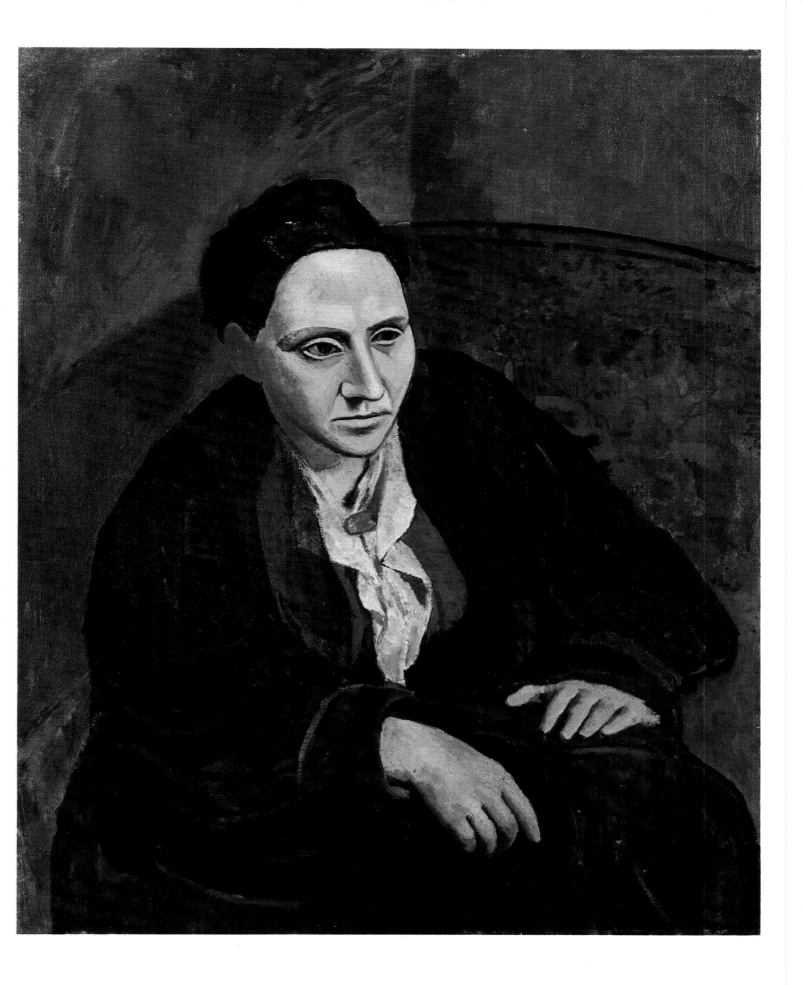

14 Self-Portrait with Palette

1906. Oil on canvas, 92 x 73 cm. Philadelphia Museum of Art (Gallatin Collection).

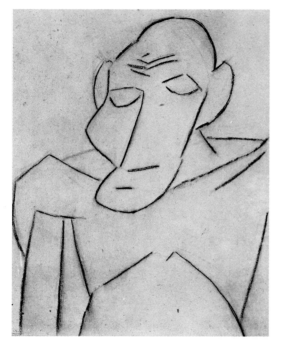

Fig. 18
Bust of a Man
(Josep Fontdevila)

1907. Charcoal on paper,
63 x 48 cm. Collection de
Menil, Houston.

Self-Portrait with Palette applies the Iberian style to Picasso himself. It portrays the artist as primitve, something already familiar from Gauguin who tried to become savage. By resorting to archaic Spanish sources Picasso appears to be reaching back to his own authentic roots (unlike Gauguin). His visit that summer to Gosol, a village untouched by modernity, was in keeping with this impetus.

This *Self-Portrait* is somewhat later than the portrait of Gertrude Stein. The stylized physiognomy is vaguely exotic, Moorish perhaps. The head, an oval poised on a ridge formed by the clavicles, is more integrated with the rest of the body than was the case in the Stein portrait. Contrasting with the bohemian *Self-Portrait of 1901* (Plate 1) Picasso now wears a simple peasant outfit and looks totally workmanlike.

Picasso was at this moment poised to make his bid for leadership of the avant garde via the audacious primitivism of *Les Demoiselles d'Avignon*. A sequence of drawings of an old man Picasso encountered in Gosol (Fig.18) leads directly to the more aggressively distorted faces of the *Demoiselles*.

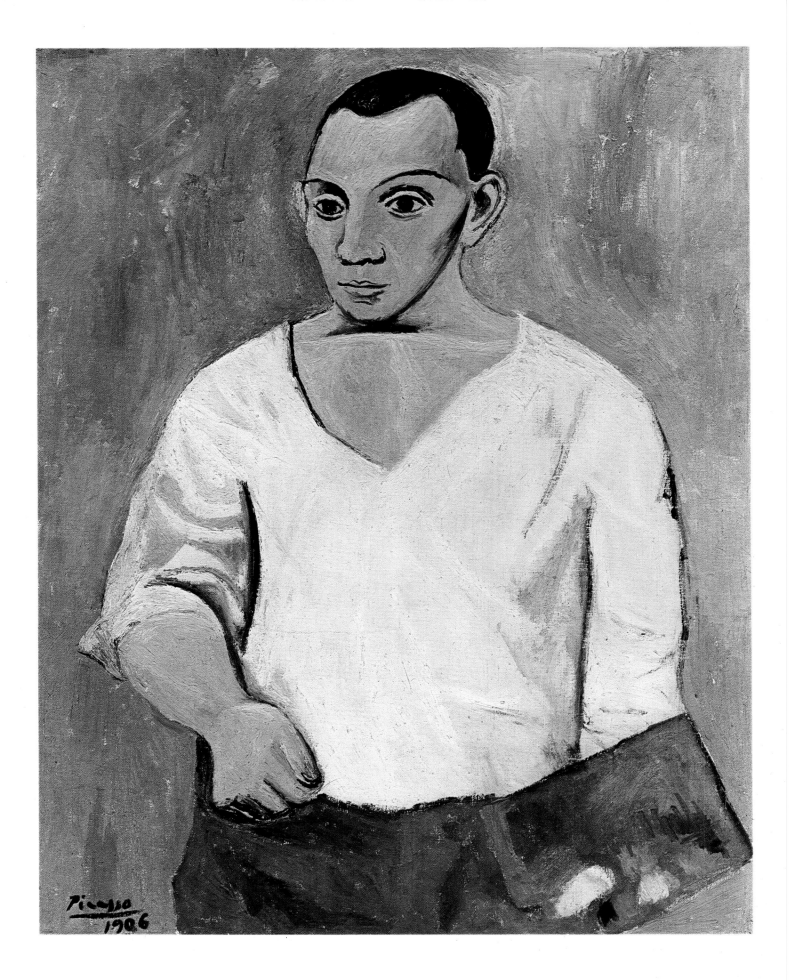

Les Demoiselles d'Avignon

1907. Oil on canvas, 243.9 x 233.7 cm. The Museum of Modern Art, New York.

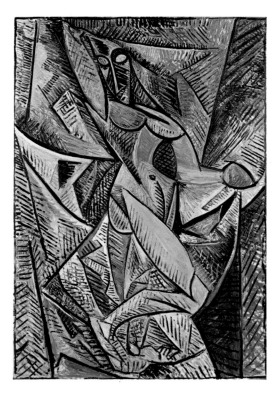

Fig. 19
Figure with Drapery

1907. Oil on canvas, 152 x 101 cm. Hermitage Museum, Leningrad.

In an essay on Picasso in 1920 André Salmon spoke of *Les Demoiselles d'Avignon* as 'the ever-glowing crater from which the fire of contemporary art erupted.' Five prostitutes confront the spectator as if we had just entered their midst – this was Manet's gambit in *Olympia*, but Picasso magnifies the scandal fivefold. No single picture better sums up the combative and iconoclastic stance of modern art.

The *Demoiselles* overturns the perspectival system that had ruled pictorial space since the Renaissance. The picture is no longer ordered with respect to a single viewpoint: bodies are fractured into parts seen from many distinct angles. This innovation is seen at a more advanced stage in *Figure with Drapery* (Fig.19), where the geometric facetting of cubism already appears in an incipient stage. The idea of making the space around figures solid like drapery may have originated from El Greco. Another important influence on Picasso was the late bather paintings of Cézanne.

Picasso painted the *Demoiselles* in two phases. A visit to the Musée de l'Homme made him aware of the power of African art and led him to repaint the heads of the three outer figures. The rawness and brutality of the *demoiselles* on the right contrasts with those in the centre which exhibit the traits of his earlier Iberian phase – the curious scroll-shaped ear derives from an Iberian bust in his possession.

The *Demoiselles* was not publicly exhibited until 1916 but was shown to fellow artists and poets who greeted it initially with shock and incomprehension.

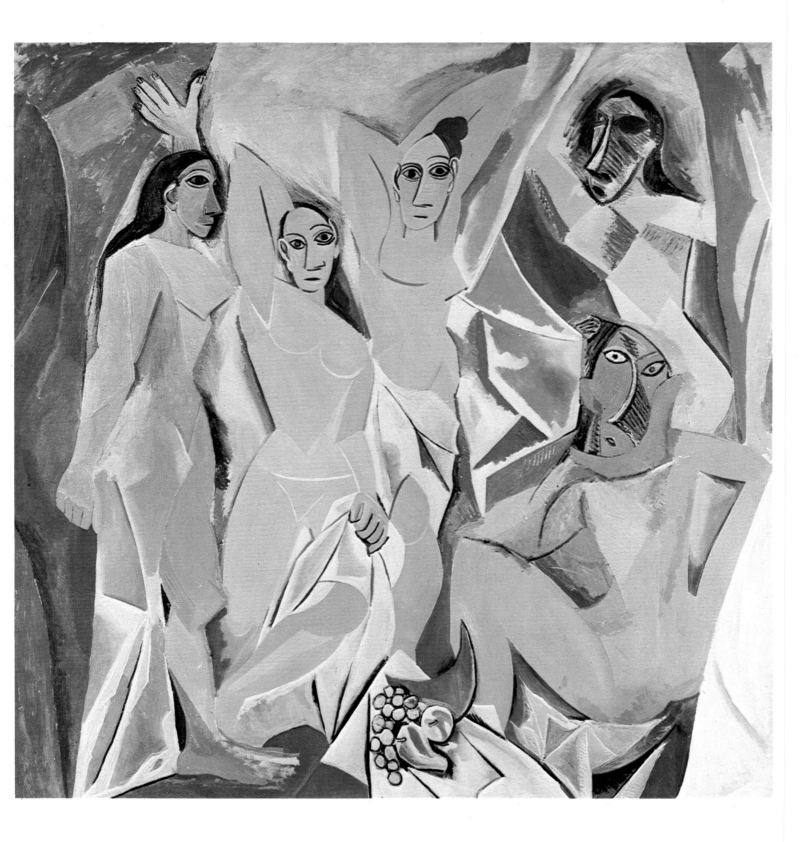

The Dryad

1908. Oil on canvas, 185 x 108 cm. Hermitage Museum, Leningrad.

Eroticism and primitivism are the salient themes of 1908. *Still Life with Skull* (Fig. 4) concerns the former. Set in the studio, it places a skull between the viewer and a study for a female nude who strikes a blatantly erotic pose. This association of death with sexuality may refer to venereal disease, which Picasso evidently had good reason to fear.

The naked crouching figure emerging from a forest canopy in *The Dryad* carries further the primitivist theme. A dryad is a wood nymph; the mask and body of the mythic creature are surely hewn from the very material she inhabits. There is a marked discrepancy of viewpoints between the two shoulders and between the torso and lower half of the body. Such distortions, which occur when an object is too close for the whole of it to be perceived at once, convey a powerful sculptural presence.

Picasso had made a number of severely geometric landscapes at La Rue-des-Bois ('the forest road') shortly before *The Dryad* and presumably invented the primeval wood nymph to inhabit them.

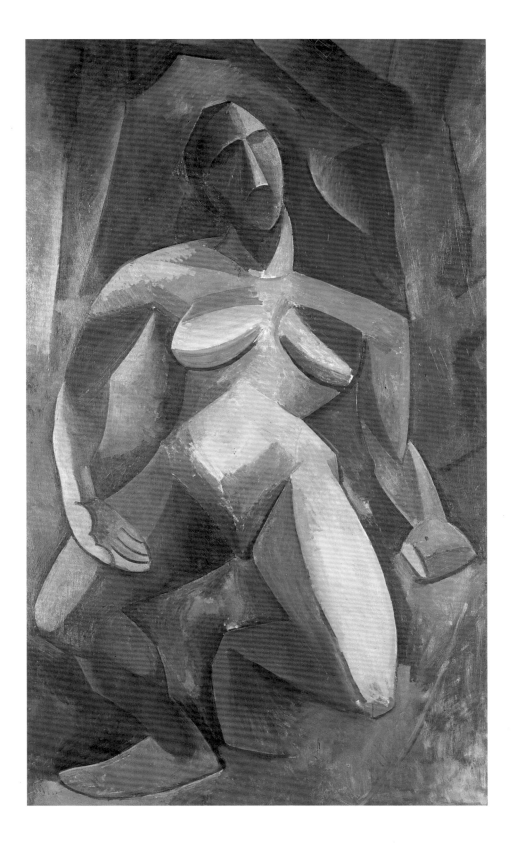

Three Women

1907 and late 1908. Oil on canvas, 200 x 178 cm. Hermitage Museum, Leningrad.

Fig. 20
**Study for Standing
Nude
(Three Women)**

1908. Watercolour and
black crayon on paper,
62 x 41 cm.
The Metropolitan
Museum of Art,
New York.

Until recently the *Three Women* has been rather neglected because of its location. Yet it is in many respects the equal of the *Demoiselles*. Like the latter, it was painted in two bouts. In late 1907 Picasso made initial studies for a five figure composition of bathers in a forest, no doubt in response to a memorial exhibition for Cézanne held at the Salon d'Automne. Two of the figures were split off as a separate picture, called *Friendship*, as the painting evolved into its present format. Studies for individual figures analyze the mass of the body into scalloped facets (Fig. 20). Their poses are unusually demonstrative and recall those of bodybuilders – and the raised arm exposing the axilla also has an established erotic meaning in high art.

The final composition unites the figures in a dense grouping, with little space visible between them. They appear fused with an adjacent rocky ledge, also brick red, as if they too were chiselled out of stone. The even facetting right across the picture plane creates an impression of low carved relief.

Three Women terminates a phase of work that began with the *Demoiselles*, to which it forms a pendant. Thereafter cubism in the pre-war years consists of works on a considerably smaller easel scale. The overt eroticism and primitivism also recedes.

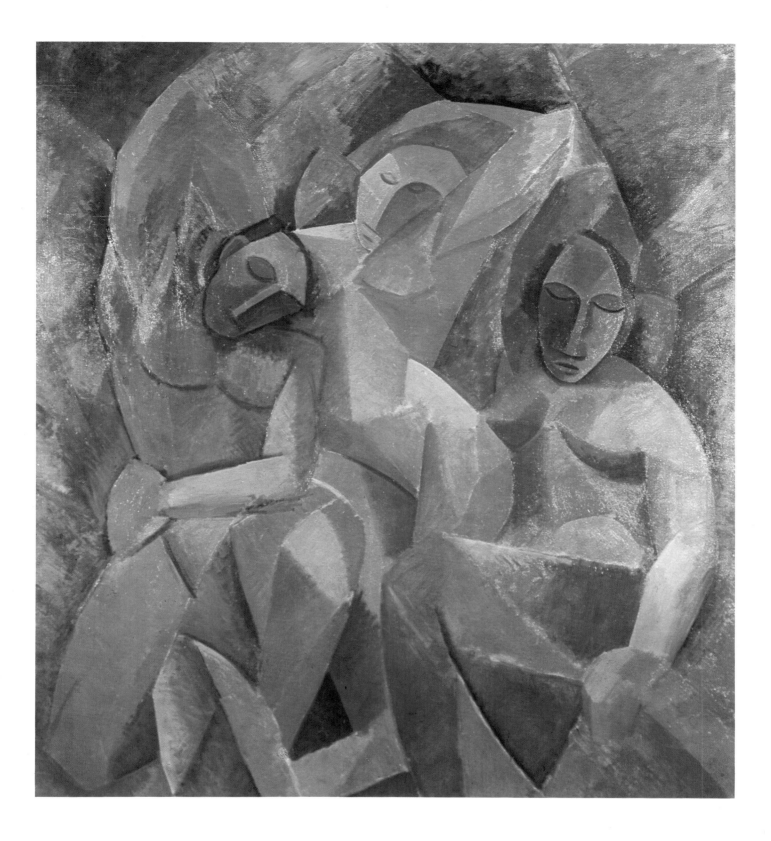

Nude in an Armchair (Seated Woman)

1909. Oil on canvas, 92 x 73 cm. Private Collection, France.

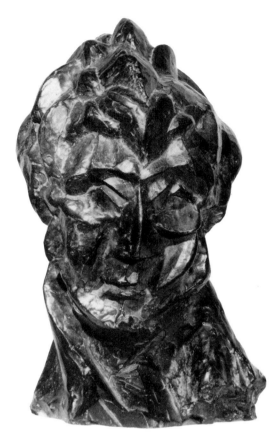

Fig. 21
**Woman's Head
(Fernande)**

1909. Bronze, 41.3 x 24.7 x
26.6 cm. Fort Worth Art
Center (Gift of Mr. and
Mrs. J Lee Johnson III),
Fort Worth, Texas.

Nude in an Armchair was painted in the summer of 1909, when Picasso and his mistress Fernande Olivier were on holiday in the isolated Spanish village of Horta de Ebro. It portrays the bust and naked torso of Fernande, who appears to be seated outdoors: in the background on the left are trees and on the right the corner of a house. The forms of her body have been analyzed into simple geometric planes, which are heavily modelled but articulate with eachother in an ambiguous reversible way, notably in the right arm. This produces a flickering effect when the eye scans the image. (Later on, it becomes difficult to identify objects with certainty in cubist pictures.)

Colour is one cue which allows us to distinguish Fernande from her background. But this distinction is eroded in other images where green is transposed from the background to the figure, and vice versa for the ochre colour, creating greater homogeneity across the canvas.

An even, flickering surface was more perfectly attained in Picasso's views of the town of Horta de Ebro. Snapshots taken at the time show how far the paintings' cubic structure was inspired by the buildings themselves. 'Cubism is a part of the daily life in Spain, it is in Spanish architecture', according to Gertrude Stein. Braque, however, had already attained similar results in his most recent French landscapes.

On his return to Paris, Picasso made a bronze bust of Fernande (Fig. 21), which transfers these cubist forms back into three dimensions.

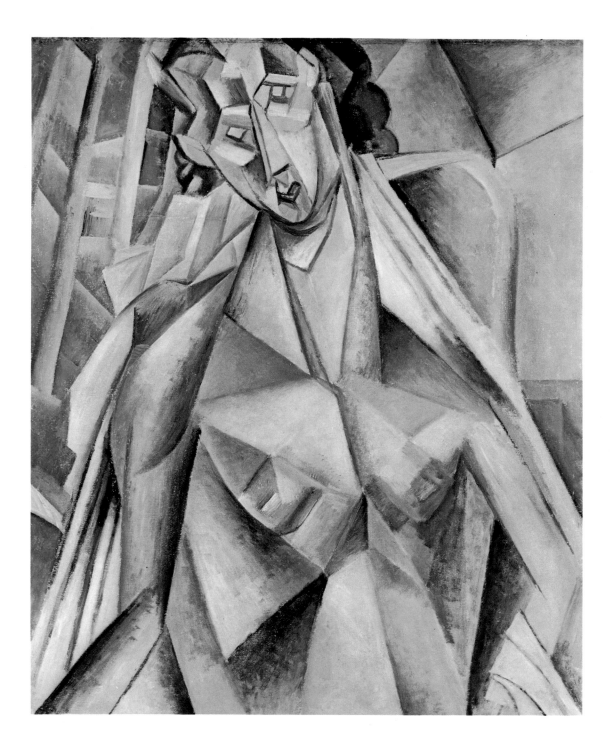

Seated Nude

1909-10. Oil on canvas, 92 x 73 cm. Tate Gallery, London.

Seated Nude carries to a final stage the fragmentation of the body into facets noted in the previous plate. The pose is also very similar, though perhaps now closer to the classical *venus pudica*. In keeping with the reference to Antique statuary, the surround of the nude acts as a sculptural niche.

The muted colours – spare touches of green and ochre in a largely monochromatic field – are a salient feature of cubism throughout the analytic phase. The silvery, nocturnal lighting has a very lyrical quality. Apollinaire wrote of Braque that, 'the mother-of-pearl of his paintings gives incandescence to our understanding.' The metallic shades and geometric forms in *Seated Nude* impose an uncanny mechanistic character on the figure.

It is a misconception that cubism offers a more objective or complete view of the world by surveying objects from several different angles. Picasso cautioned that the realism of cubist painting is elusive and impalpable, like a perfume. Cubism in fact owes much to the persistence of symbolist attitudes into the first decade of the century. Instead of treating art as a mirror of nature, symbolism stressed the subjective vision of the artist.

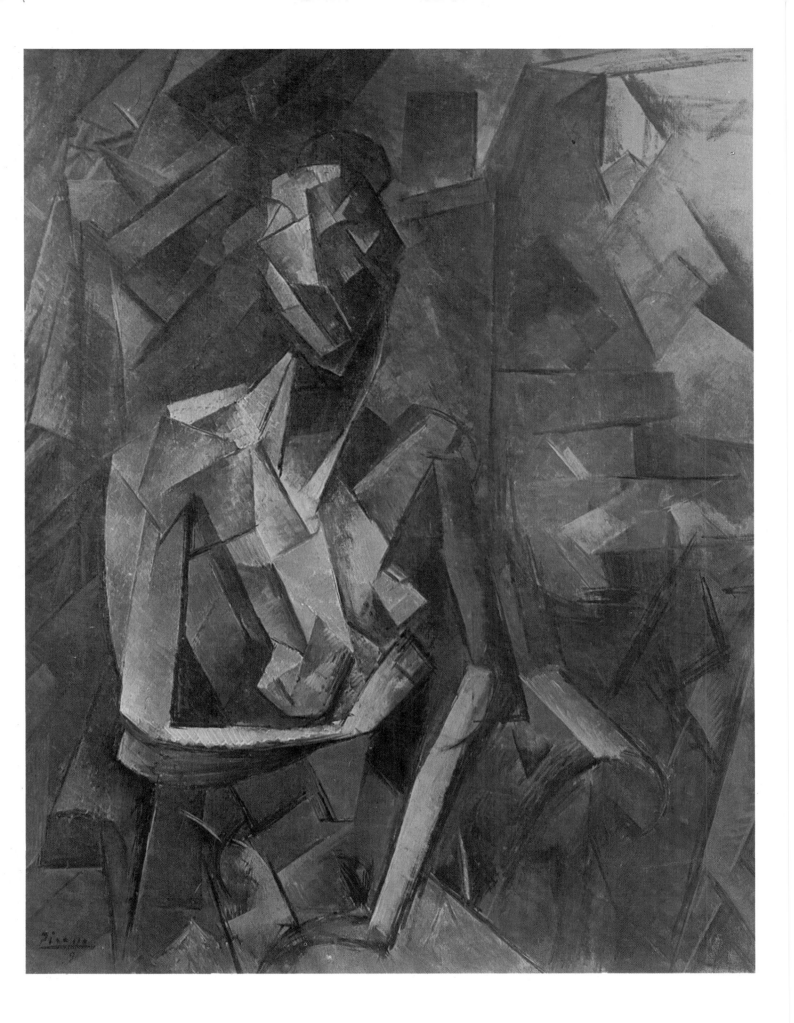

20 Nude

1910. Oil on canvas, 99.1 x 78.1 cm. Albright-Knox Art Gallery, Buffalo, New York.

This image shows clearly the emergence of a cubist grid or scaffold, oriented with respect to the edges of the canvas. By echoing the outer limit of the picture this device draws attention to the painting as a discrete object, separate from the world it represents. Within the picture these lines demarcate various planes situated in space. The figure has likewise been built up from a simple structural armature, its basic verticals and diagonals conforming to the background planes. The contour of the body is incomplete and at these points the figure, now quite transparent, melds into its glassy surround.

Curves and painted highlights are used around the hip and shoulder regions. These points of articulation attract close attention because Picasso has attempted to render the figure in motion. The use of cubist devices to suggest movement was exploited by the Italian futurists, and notably by Marcel Duchamp in his famous *Nude Descending a Staircase*.

Attempts have been made to relate the peculiar space and transparency of objects in cubist pictures to such contemporary developments as the invention of X-Rays.

However, the surrealist poet André Breton touches on the essence of these grand paintings when he writes of Picasso that, 'In his case, the rigid scaffolding of so-called "analytic" cubism was very soon seen to be rocked by high winds, to be haunted. In this period of his work which I consider to be the most fascinating of all, the power of incantation shows no sign of diminishing.'

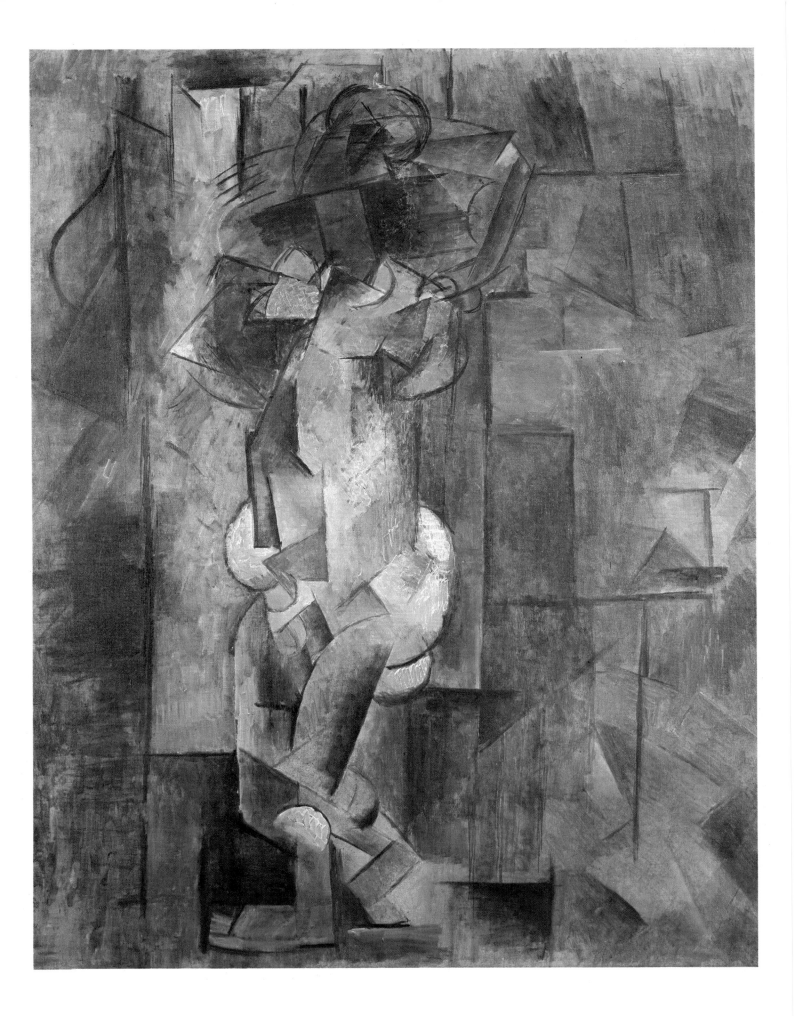

Portrait of Daniel-Henry Kahnweiler

1910. Oil on canvas, 100.6 x 72.8 cm. Art Institute of Chicago (Gift of Mrs.Gilbert W. Chapman).

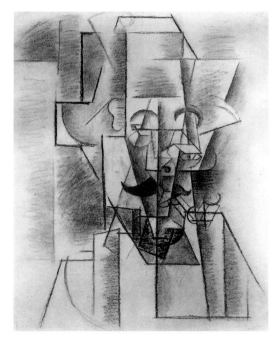

Kahnweiler was the dealer for the principal cubist painters before the First World War. He signed exclusive contracts with painters, agreeing to buy all their work. In return he discouraged them from exhibiting in public salons. These business practices may have contributed to cubism's hermetic character; they certainly meant that the work of Picasso and Braque was largely invisible in the public arena, although they were widely acknowledged as the inventors of the style.

This picture is one of the masterpieces of high analytic cubism. It is composed of crystalline planes that hover ambiguously in a space that permeates even the figure. A shorthand system of signs disposed on the main scaffold is enough to indicate the main features of the sitter – Picasso's eye as a caricaturist for the telling detail is exploited here to the full. These linear elements can be better appreciated in drawings and etchings (Fig. 22).

The painted passages are of exquisite beauty. Picasso outlined his technique in a letter to Braque: 'For the new canvas, very thinned out pigment to start with and [then] the methodical technique of the Signac type [with] scumbling only at the end.' *Portrait of Kahnweiler* was painted soon after Picasso returned from holiday in Cadaqués on the Spanish coast, and Roland Penrose is surely right to find hints of architecture silhouetted against the shimmering sea.

1912. Charcoal, 62.2 x 47 cm. Collection Dr. and Mrs. Israel Rosen, Baltimore, Maryland.

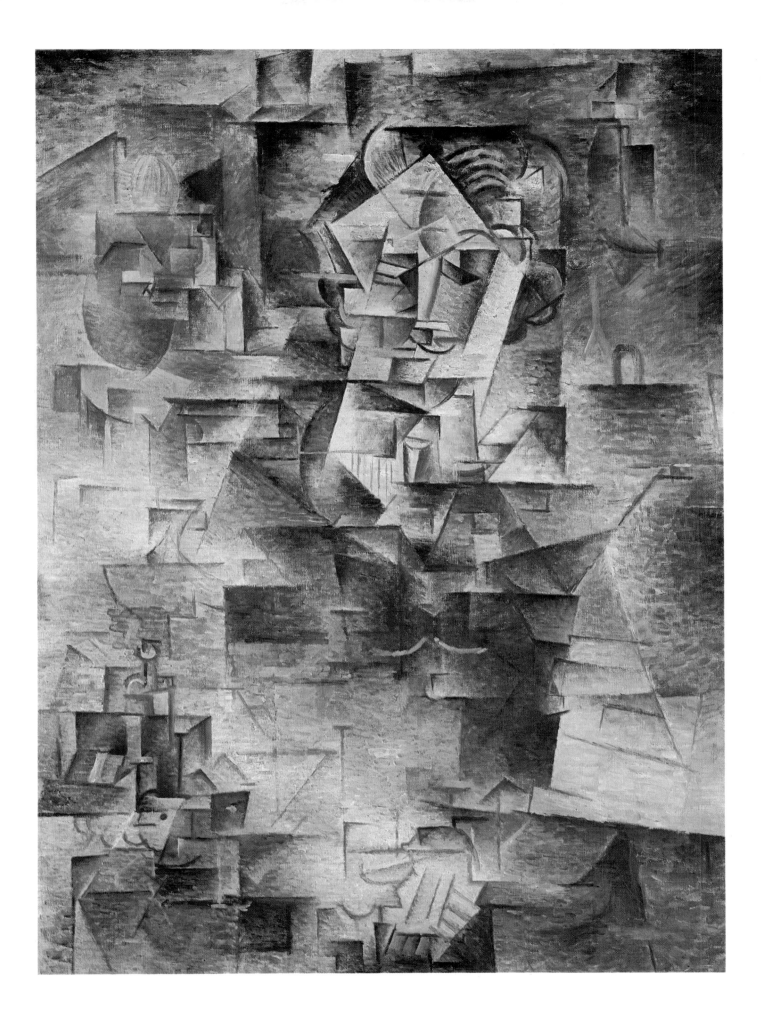

Violin and Grapes

1912. Oil on canvas, 50.6 x 61 cm. The Museum of Modern Art, New York.

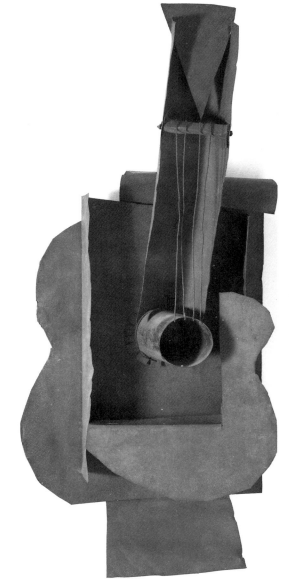

Cubism was greatly enriched in the course of 1912. Most visibly, colour crept back into the monochrome field of high analytic cubism. The addition of sand to paint, and the imitation of wood graining, created a textured and variegated surface. Many of these innovations were due to Braque, who was trained as a house decorator; he was the first to use the housepainter's comb to produce a *faux bois* pattern. Picasso, taking up the cue, uses the instrument not only for wood-graining but also to paint or 'comb' hair. In *Violin and Grapes*, he manages to combine at least four different ways of denoting a wooden surface!

The witty visual dialogue between Picasso and Braque reached a new pitch in 1912; Salmon recollected that, 'We invented an artificial world with countless jokes, rites and expressions that were unintelligible to others.' The many references to music in their painting are partly a vestige of symbolism, but the incorporation of musical instruments was also a prime opportunity to indulge a taste they shared with Apollinaire for punning visual rhymes: between the guitar and a woman's body or – when it is turned on end – a face (see Fig. 24).

In the winter of 1912 Picasso constructed a *Guitar* out of sheet metal (Fig. 23), inaugurating a new form of open sculpture.

Fig. 23
Guitar

1912-13. Sheet metal,
string and wire
construction,
77.5 x 35 x 19.5 cm.
The Museum of Modern
Art, New York.

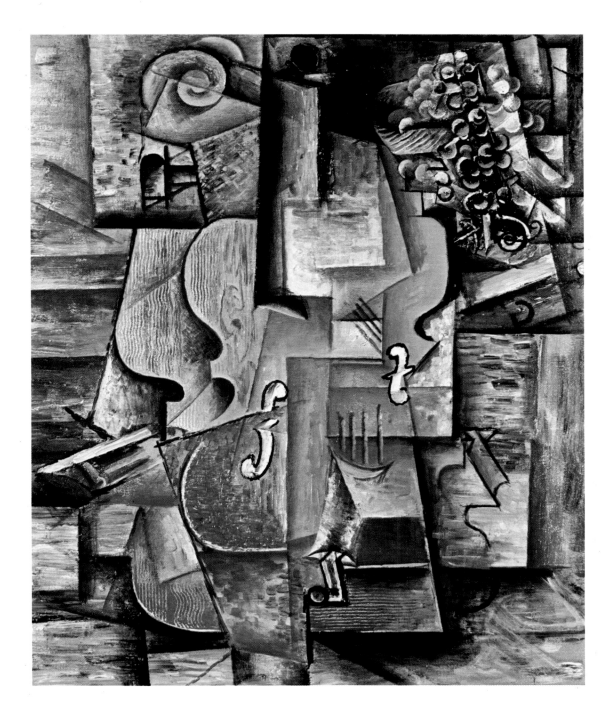

Guitar, Gas-Jet and Bottle

1913. Oil, sand and charcoal on canvas, 68.5 x 53.5 cm. Private Collection, London.

Fig. 24
Man with a Hat

1912. Pasted paper,
charcoal and ink, 62.2 x
47.3 cm. The Museum of
Modern Art, New York.

In the latter part of 1912 Braque once again stole a march on Picasso by pasting in wood-grained wallpaper to indicate the background of a still-life drawing. This was the first *papier collé*. The new technique enabled large planes of colour to be combined with linear elements drawn in charcoal, as in *Man with a Hat* (Fig. 24). Furthermore, the inclusion of newspaper cuttings now permitted reference to outside political events, to popular culture and so on, to intrude into the hermetic, aesthetic world of cubist still life.

Transferring these effects to painting accounts for the appearance of synthetic cubist pictures such as *Guitar, Gas-Jet and Bottle*. The spare linear elements are so schematic as to be almost arbitrary – a circle can refer equally to the sound hole of a guitar and to the rim of a glass to its right. Picasso is now sufficiently emboldened to confront cubism with the old naturalistic methods by painting in a bottle at the right: its contents must be poured into the adjacent cubist cup to be drunk! The paradox is compounded by the shadows each of them casts.

The everyday assortment of objects in cubist pictures such as *Guitar, Gas-Jet and Bottle* afford the excluded spectator a privileged glimpse inside bohemia: 'what could be more familiar to a painter or painters of Montmartre or Montparnasse, than their pipe, their tobacco, the guitar hanging over the couch, or the soda bottle on the café table?' asked Picasso.

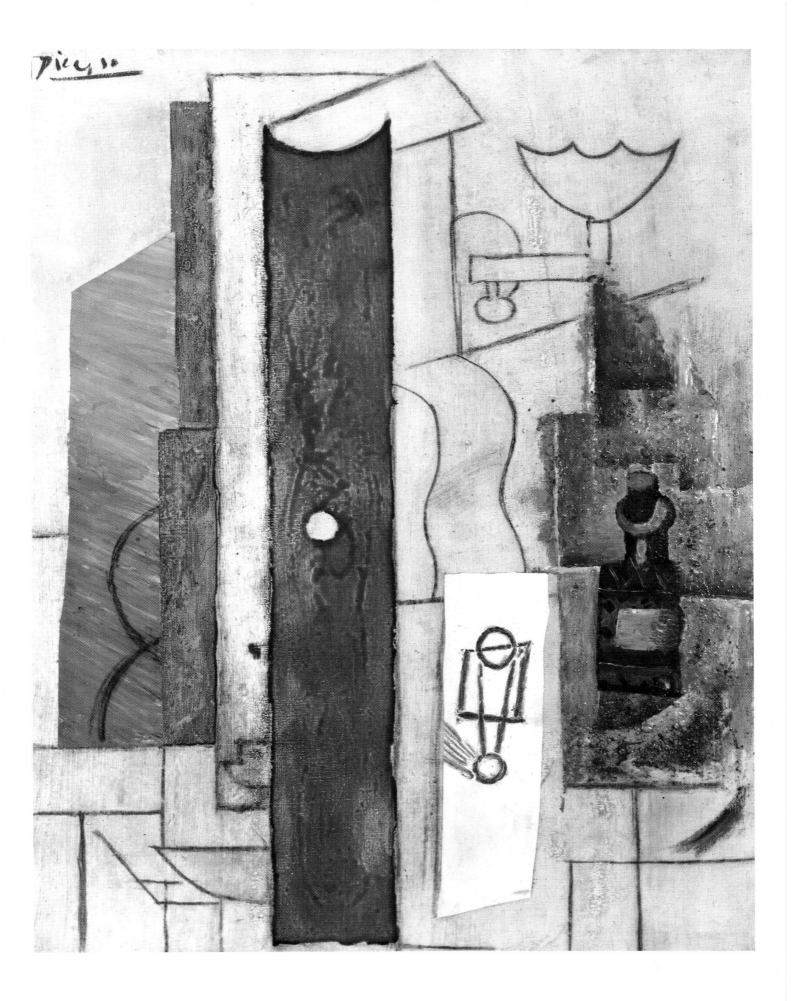

Still Life with Cards, Glasses and a Bottle of Rum: 'Vive la France'

1914-15. Oil and sand on canvas, 54.2 x 65.4 cm. Mr. and Mrs. Leigh B. Block, Chicago.

The pictures Picasso painted in the summer of 1914 in Avignon are the climax of pre-war cubism. He piles everything into *Still Life*, which has in consequence a frenetic Baroque exuberance. The baseline colour – a sumptuous Matissean green – is counterpointed with rich floral wallpaper and pointillist dots borrowed from Seurat. A naturalistic curtain is drawn back to reveal a jumbled inventory of long familiar cubist objects: playing cards (which allude to a famous poem by Mallarmé), glasses (one has an elliptical rim as if seen in perspective), pears (one cubist and one naturalistic), and a bottle of rum, to which he adds a vase of flowers painted in mock naive style. Amid this clowning Picasso repeats a joke from an earlier picture (Fig. 6): the letters 'JOUR' are exerpted from the title of a newspaper present in the still life, *Le Journal*. But the shortened form puns on *jeu* (game) and *jouer* (to play), and hence it is a comment on the high buffoonery of the work as a whole.

A whimsical construction of a cubist still life (Fig. 25), which comes complete with its own background wall and 'frame', extends this cleverness into three dimensions.

On the side of a cup at the left of the painted still life is 'VIVE LA' above two tricolore flags. The war had broken out and Braque had been conscripted. And so one of the most inventive moments in Western art was brought to a close.

Fig. 25
**Still Life
Construction**

1914. Painted wood construction with upholstery fringe, 25.4 x 45.7 x 9.2 cm. Tate Gallery, London.

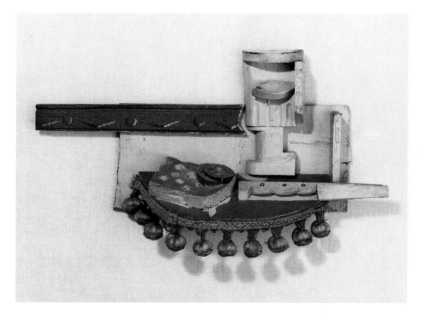

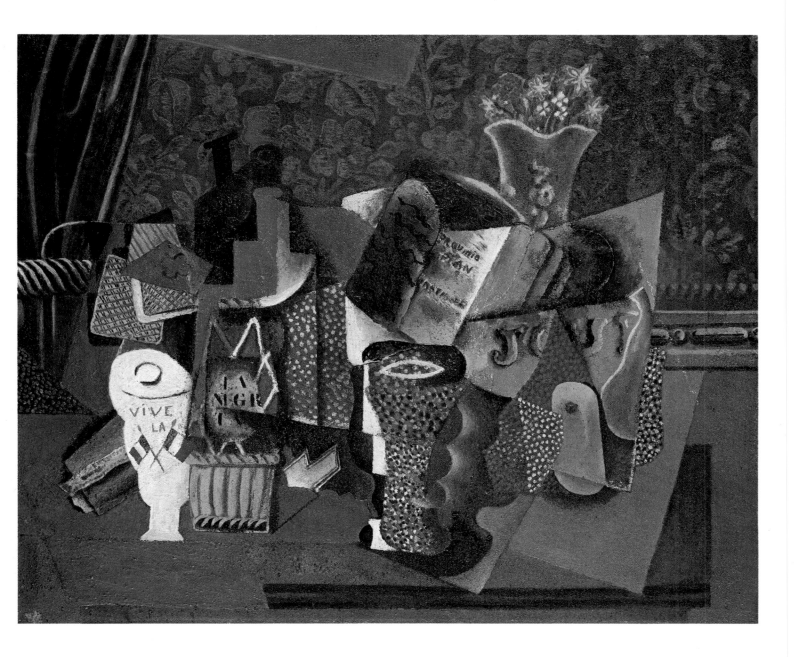

Harlequin

1918. Oil on canvas, 147 x 67 cm. Joseph Pulitzer Collection, St.Louis, Missouri.

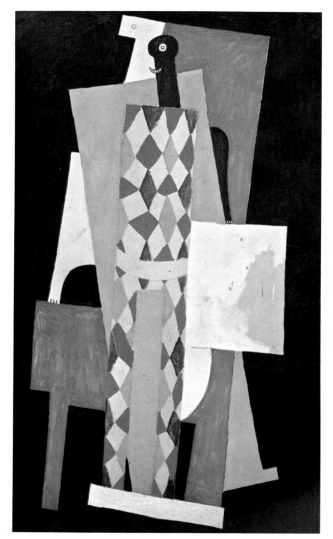

Fig. 26
Harlequin

1915. Oil on canvas, 183 x 105 cm. Museum of Modern Art, New York.

Picasso's attraction to motifs from the Commedia dell'Arte, so conspicuous in the Rose Period, was rekindled a decade later. In 1917 he travelled to Rome where he worked on *Parade*, a ballet about the world of circus sideshow, and while in Italy he attended performances of the Commedia dell'Arte in Naples with Stravinsky (see Fig. 30).

Recalling the popularity of Commedia subjects after the First World War, the cubist sculptor Jacques Lipchitz wrote that, 'Pierrots and harlequins were part of our general vocabulary.' The Commedia provided an opportunity to rehabilitate a traditional subject within a modern idiom: the artifice of late cubism well suited themes of disguise and masquerade.

Picasso stands somewhat apart from the more general vogue because of the personal level of meaning he infuses into stock Commedia types. In 1915 the general misery of wartime was aggravated by the illness of his mistress, Eva Gouel, who died soon afterward from tuberculosis. *Harlequin* (Fig. 26) resonates with deep despair: the figure is precariously tilted and set amid an ominous dark surround. A blank canvas held by harlequin indicates the creative blockage arising from his unbalanced state.

The mood had lightened considerably by 1918. This later *Harlequin* demonstrates the remarkable versatility of cubism at the end of the war, notable in the diversity of means used to render the head. It is typical of this period that flat overlapped planes occupy a highly compressed space.

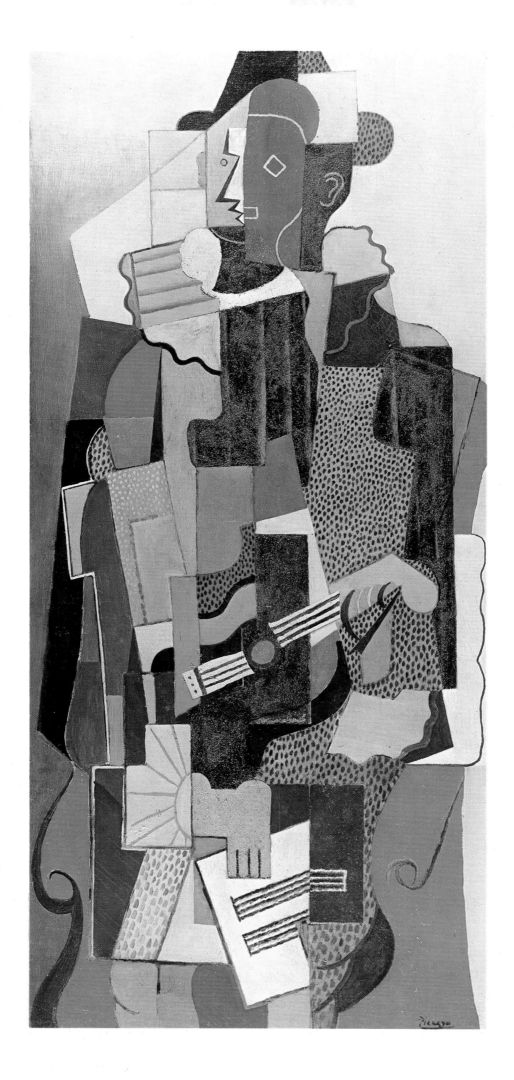

Still Life on a Table

1920. Oil on canvas, 165 x 110 cm. Location unknown.

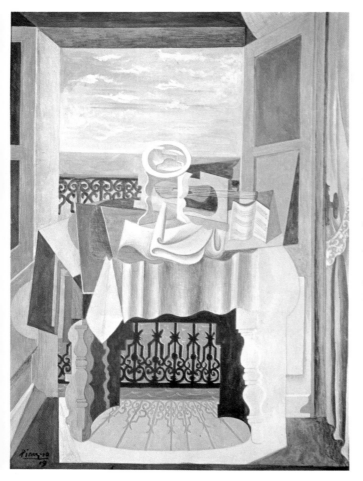

Fig. 27
Open Window at
St. Raphael

1919. Gouache on paper,
35 x 24.8 cm. Private
Collection, New York.

Cubism explored mainly the confined space of still life. During the synthetic phase, after 1912, indications of depth are limited to the overlapping of flat planes. In 1915 Juan Gris confronted the shallow space of cubism with the depth of landscape by posing his still life before a window with a view onto the rue Ravignan in Montmartre. One effect of opening out the picture was to create a visually exciting mix of inner and outer spaces. In *Open Window at St. Raphael* of 1919 (Fig. 27), Picasso exploits the opportunity to juxtapose in a single picture the cubist and naturalistic manners in which he had worked separately since 1914. The still life component is based on a tiny cardboard construction.

Still Life on a Table – with a view of the rue de Penthièvre in Paris – contains many of the same elements, only they have been shuffled like pieces of a jigsaw waiting to be solved by the viewer. The round *gueridon* table appears in many late still lifes by Braque. Upon it is placed a *compotier* (fruit bowl) and a guitar as well as a row of house façades from the background! These objects are framed as if to create a second picture within the picture, adding another twist to the pictorial puzzle.

The discordant vitality of *Still Life on a Table* is evidence of the continued life of cubism after the war. One new development was the introduction of curved organic shapes from 1923 onwards.

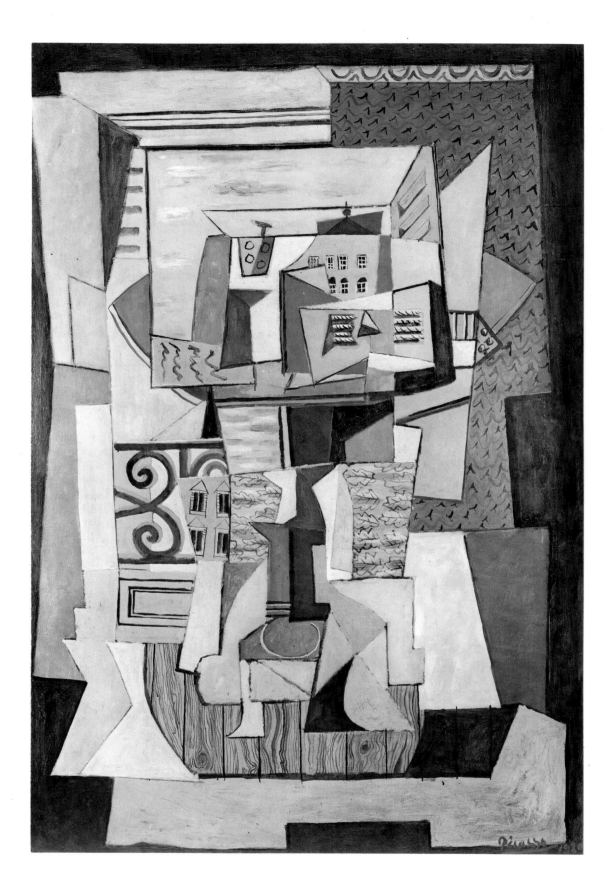

The Rape

1920. Tempera on panel, 24 x 33 cm. The Museum of Modern Art (The Philip L. Goodwin Collection), New York.

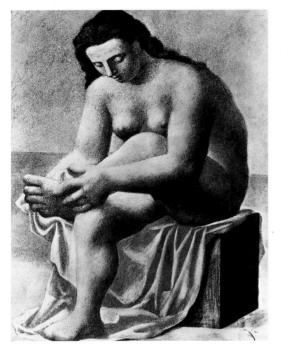

Fig. 28
Seated Woman
Drying her Foot

1921. Pastel, 65 x 50 cm.
Berggruen Collection,
National Gallery, London.

The Rape is a picture in quotation marks, a single line excerpted from some grand historical narrative. The drama of this tiny tableau, a *scène de guerre*, resides in the imploring attitude of a woman torn away by her abductor from the fallen warrior who lies on the ground. One is reminded that in the wake of the First World War it was left for France to count the cost of victory and mourn her dead.

Theodor Adorno remarked that, 'museums and mausoleums are connected by more than phonetic associations'. The Louvre which had shut during the war, was reopened by stages in 1919 and 1920. Avant garde artists who had previously vowed to raze this grand repository of French culture now returned in droves. The attempt to revive classical subjects and styles – the *rappel à l'ordre* – is pervaded by a sense of mourning for a past which had been irrevocably severed by war.

The Rape is one of several tempera panels of classical subjects from 1920. The ponderous figure style and terracotta colours are unmistakably archaic and recall frescoes Picasso might have seen on his 1917 visit to Pompeii. A pastel *Seated Woman Drying her Foot* of 1921 (Fig. 28) exhibits the solemn grandeur typical of the period; her pose is a textbook citation from the Roman *Spinario*, or boy removing thorns from his foot.

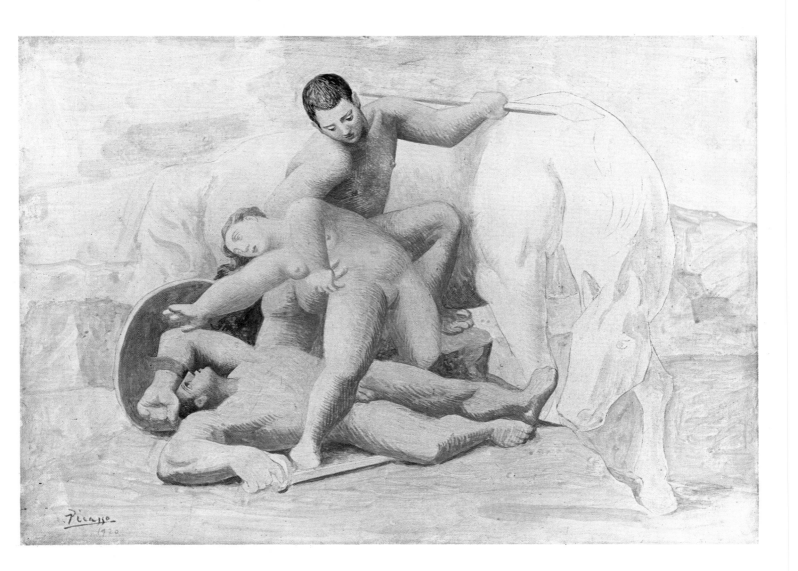

Three Musicians

1921. Oil on canvas, 203 x 188 cm. Museum of Art (Gallatin Collection), Philadelphia.

Conservative critics who abhorred the ferment of the pre-war years took heart from the return to tradition and wasted no time burying cubism.

In 1921 at Fontainebleau Picasso painted a large canvas of three women at a fountain, executed in a ponderous archaic style suited to its traditional subject of woman as source (Fig. 29 is related to this). At the same time he painted the *Three Musicians*, an exact counterpart that confronts it with a jazzy version of his late cubist style. Picasso could not have made a clearer statement than this that he had not forsaken pre-war cubism in the return to classicism.

Theodore Reff has proposed an ingenious reading of the *Three Musicians* as a nostalgic tribute to the heady years of pre-war cubism. Apollinaire had died from influenza in 1918 while Max Jacob, Picasso's other poet ally, underwent religious conversion and entered a Catholic monastery. So the artist was feeling very much alone. The ostensible subject of the *Three Musicians* is one of the masked balls that enjoyed a fad among the *beau monde*. Reff identifies the trio with the former *bande à Picasso*, with Jacob as the monk on the right, Apollinaire as Pierrot in the middle and Picasso obviously in the guise of harlequin. The lacuna that was left by the departure of these comrades would later be filled by a younger generation of surrealist poets.

Fig. 29
Three Women at a
Fountain

1921. Oil on canvas,
19 x 24 cm. Berggruen
Collection, National
Gallery, London.

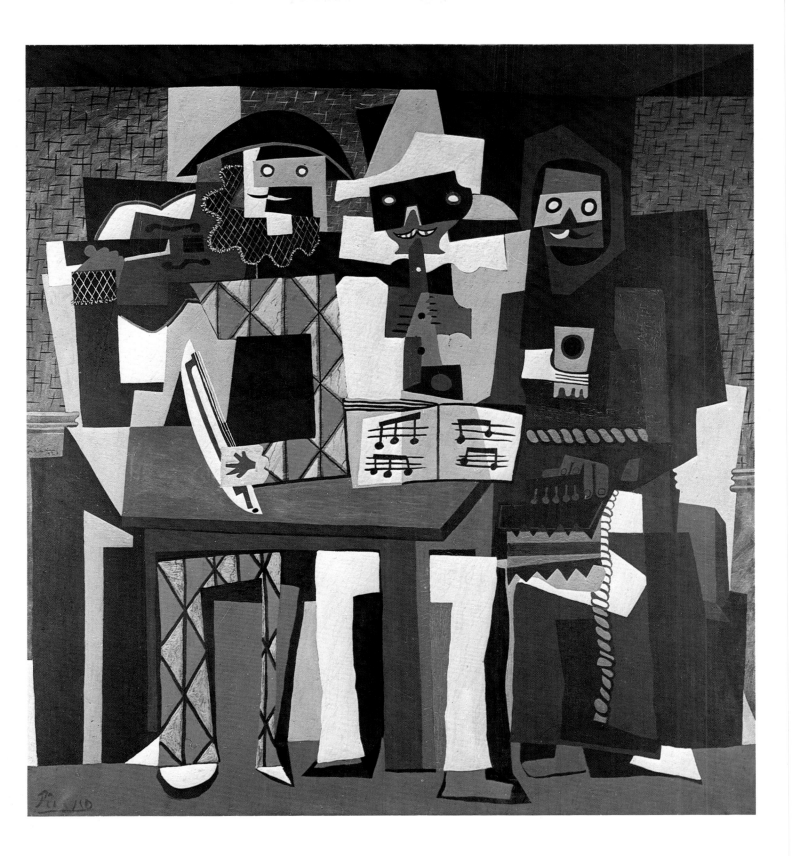

The Lovers

1923. Oil on canvas, 130 x 97 cm. National Gallery of Art (Chester Dale Collection), Washington, D.C.

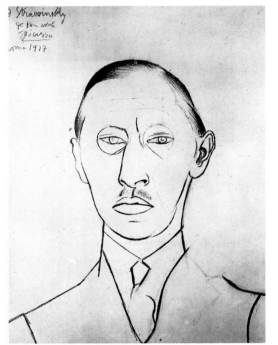

Fig. 30
Portrait of
Stravinsky

1917. Pencil, 27 x 20 cm.
Private Collection, New
York.

The curtain Picasso designed for the ballet *Parade* in 1916 afforded the first public glimpse of his return to classicism, and his use of a classical style from this point onwards is best understood in the context of theatre. Jean Cocteau, who was the key intermediary between Picasso and the world of theatre, revelled in a fashionable pastiche of past styles. His notion of style *as* theatre closely corresponds to Picasso's own.

On the surface, the classicism of *The Lovers* appears beyond reproach: its pure lines and unsullied colours are surely classical in their restraint. And the chiselled features and marble flesh of this embracing couple could be the work of any antique sculptor. Yet our perception of the image is significantly altered by the theatrical setting. Not only are the lovers just actors and their love feigned, but the style itself is a mere contrivance.

Contemporary critics sensed that the exaggerated bulk of figures such as *Seated Woman Drying Her Foot* (Fig. 28) verges on parody, and the bizarre distortions of *Two Bathers* (Fig. 9) which purports to be classical, are a far cry from any classical norm of beauty. In addition we have seen how Picasso oscillated willfully between cubism and classicism after the war. Thus his version of a *rappel à l'ordre* was far from straightforward.

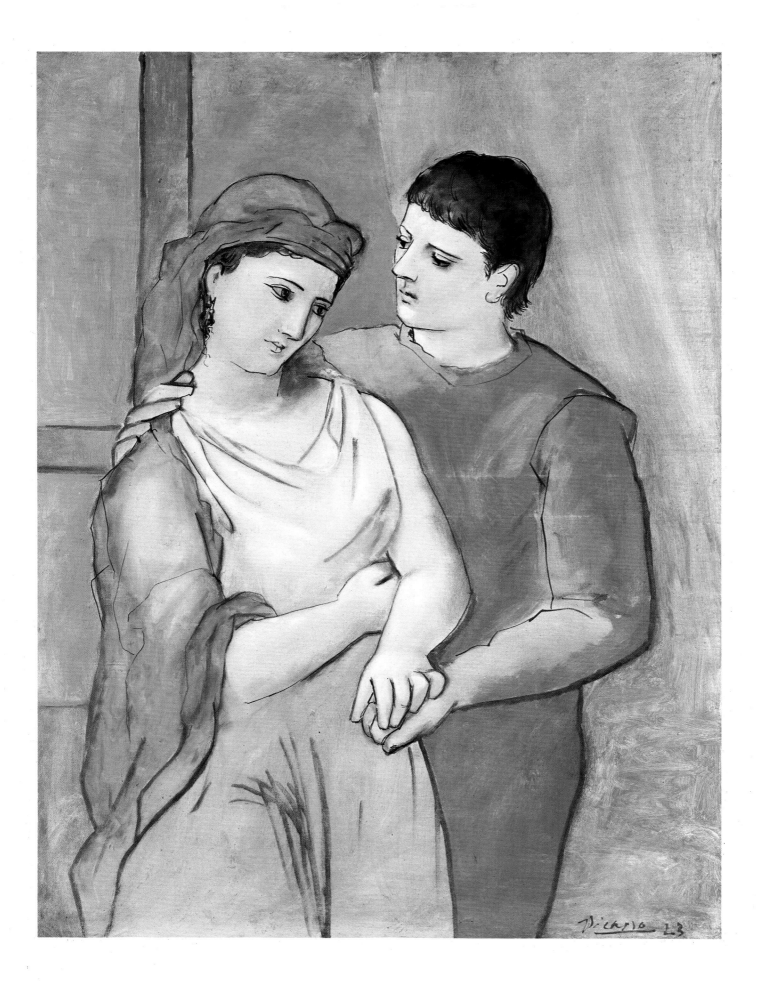

Portrait of Olga

1923. Oil on canvas, 101 x 82 cm. National Gallery of Art (Chester Dale Collection), Washington, D.C

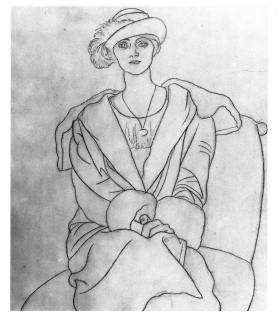

Fig. 31
**Olga with a Hat
with a Feather**

1920. Pencil on charcoal
outlines, 61 x 48.5 cm.
Musée Picasso, Paris.

In Rome Picasso fell in love with a dancer from the Ballets Russes, the daughter of a Russian colonel – Olga Koklova. He accompanied her to Barcelona and in the summer of 1918 they agreed to marry. The couple then moved to a fashionable apartment on rue la Boétie, a reflection of Picasso's growing prosperity.

Her classical beauty made Olga an ideal accompaniment to the changes occurring in Picasso's art. A pencil drawing from 1920 (Fig. 31) follows her elegant contours with a coldly precise line borrowed from Ingres, the nineteenth-century master whose classicism exudes an austere, rigid perfection. In the 1923 *Portrait of Olga* this sobriety marries well with the decorous, rather haughty demeanour of the sitter, whose affluence is not in doubt. Though classical it is nonetheless resolutely modern in subject and style: the spontaneous drawing, directly applied wash of paint and scratched surface would have scandalized Ingres.

By the latter part of the decade their relationship had soured. Olga, the former classical beauty, now appears in his art as a shrieking maenad!

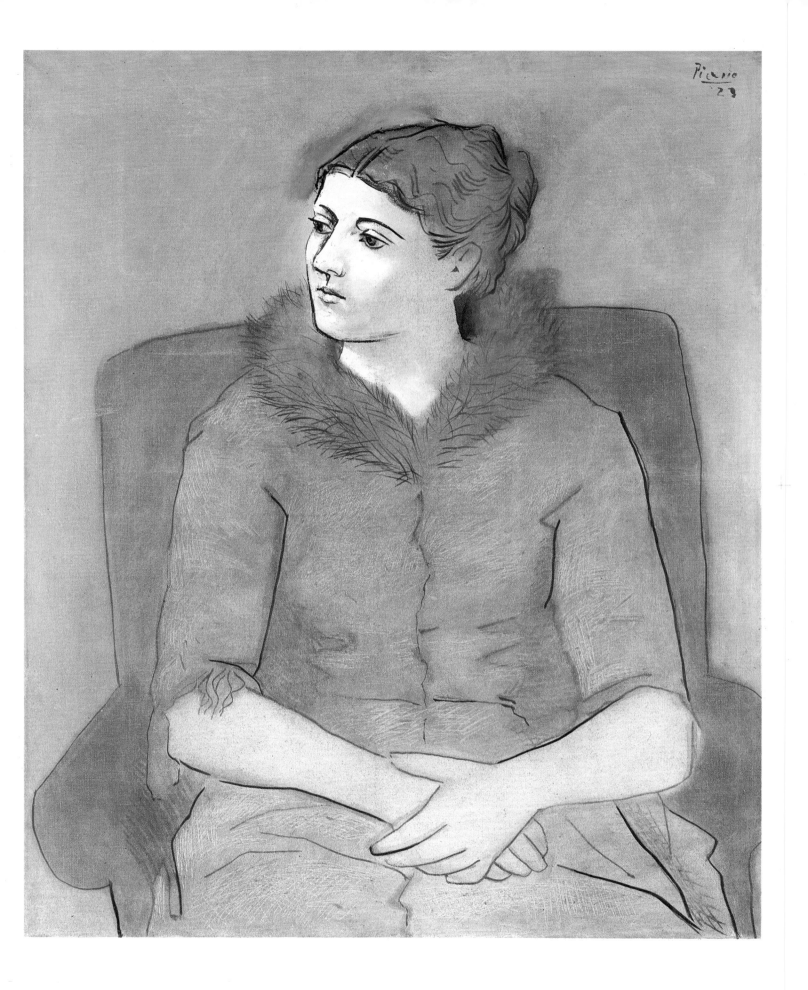

Woman with a Mandolin

1925. Oil on canvas, 130 x 97 cm. Formerly in the collection of Alexandre Paul Rosenberg.

This subject harks back to cubism before the First World War: Picasso first depicted it in 1909 and the following year he painted *Girl with a Mandolin* (Fig. 5). The lyrical meditative quality of the picture is reminiscent of Corot, whose captivating images of peasant girls handling musical instruments were the main impetus for this stock cubist subject. Twenty-four of his figure paintings were exhibited at the Salon d'Automne in 1909.

One consequence of the war was a paranoid suspicion of anything foreign, including cubism. In this context, Corot's reputation soared as the calm sobriety of his art came to epitomize truly French qualities. As a Spaniard Picasso was bound to be wary of this assertion of Frenchness; Corotesque motifs nevertheless creep back into his art from 1917 onwards.

In *Woman with a Mandolin*, not only does the subject allude to Corot, but the erect pose and treatment of the face also suggest a classical source. This is combined, however, with the broad coloured planes of synthetic cubism. It may be that Picasso was attempting to fudge the distinction between cubism and classicism, and to reclaim Corot for himself. This is more clearly the case in some related cubist still lifes that include classical busts and musical instruments. However it would not be out of place to compare this picture, and the similar *Reclining Dancer with Tambourine*, with the scores of female nudes painted in watered down variants of the cubist style by School of Paris artists between the wars.

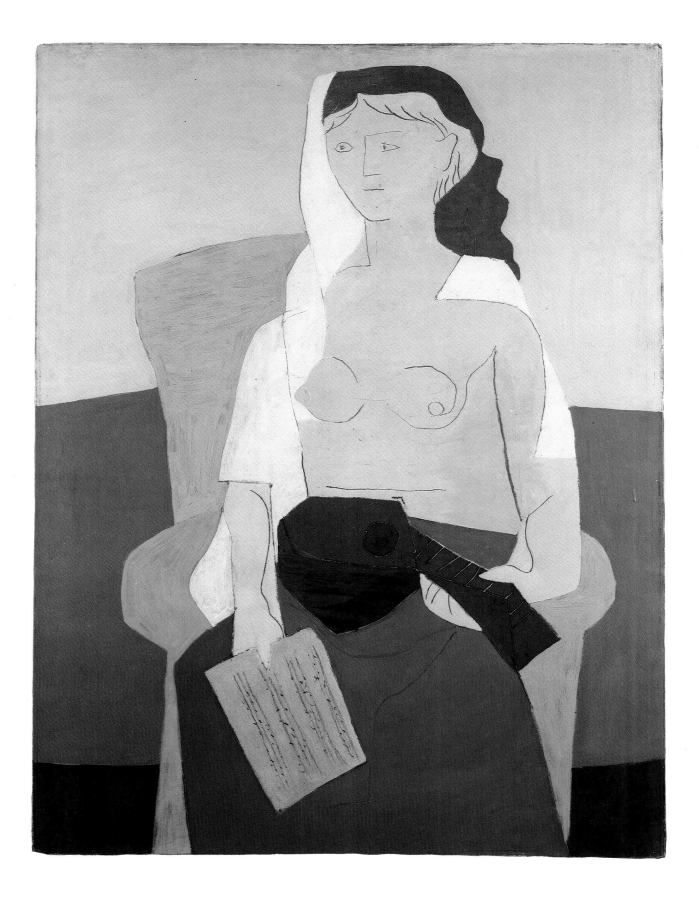

The Three Dancers

1925. Oil on canvas, 215 x 143 cm. Tate Gallery, London.

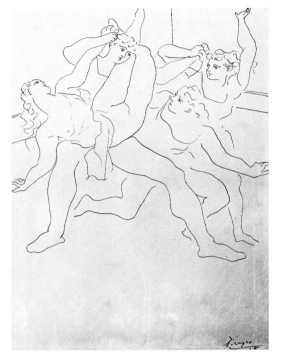

Fig. 32
**Four Ballet
Dancers**

1925. Pen and ink, 35 x 25
cm. The Museum of
Modern Art, New York.

'We claim him [Picasso] unhesitatingly as one of us', proclaimed André Breton in 1925 in an essay entitled *Surrealism and Painting*. The leader of the surrealists justified his annexation of Picasso by reproducing *The Three Dancers* beside his article.

Comparing *The Three Dancers* with another image of the same year, *Four Ballet Dancers* (Fig. 32), it can be seen that one is Apollonian in its serene perfection while the other is agitated, convulsive, Dionysiac. Nietzsche had described just such an antithesis within classical culture in *The Birth of Tragedy*, a book Picasso may have encountered as a youth in Barcelona.

The central figure of *The Three Dancers* adopts a crucifixion pose which certainly conveys a tragic, ritualistic air. Many aspects of the picture are obscure, however. Following clues offered by Picasso, an autobiographic layer of meaning has been proposed: the suggestion is that it relates distantly to the death of Casagemas, memories of which may have been revived by the recent death of another painter friend, Ramon Pichot. His wife Germaine was apparently the lover of Casagemas who committed suicide because of his impotence – hence the androgynous figure and castrating maenad. The prominent doorknob recurs as a private symbol in later surrealist works by Picasso.

The Three Dancers does not share the concern of surrealist painters such as Masson or Ernst to find a painted equivalent to automatic poetry (an undirected record of unconscious thought). Though Breton's claim was premature, it did produce the effect he desired: for the next decade surrealism would be the main support for Picasso's art.

Seated Bather

1930. Oil on canvas, 164 x 130 cm. The Museum of Modern Art, New York.

In 1930 the surrealist writer Georges Bataille wrote of 'a bizzare but mortal subversion of the ideal and of the order expressed today by the words "classical antiquity"'. His words are an apt description of the *Seated Bather* which evokes memories of a classical motif in order to dismember it. *The Mediterranean*, a classical figure by Aristide Maillol, may be the specific icon that Picasso set out to subvert (a marble version commissioned by the State was completed in 1929).

The hollow forms of *Seated Bather* are hard and skeletal. A menacing vice-like countenance and stick arm recall the surrealists' fascination with the praying mantis. Writing in the surrealist periodical *Minotaure*, Roger Caillois marvelled at the weird anthropomorphism of the mantis, and its capacity to function even when decapitated.

Picasso metamorphoses a bather, redolent of classical antiquity, into a bestial and mechanistic contraption. The following year he was assailed by a right wing supporter of Maillol, Waldemar George, who protested that 'The chimeras of Pablo Picasso are destined to be dumb still lifes... assemblages of form and colour, but not sources of energy or foci of a Mediterranean civilisation.'

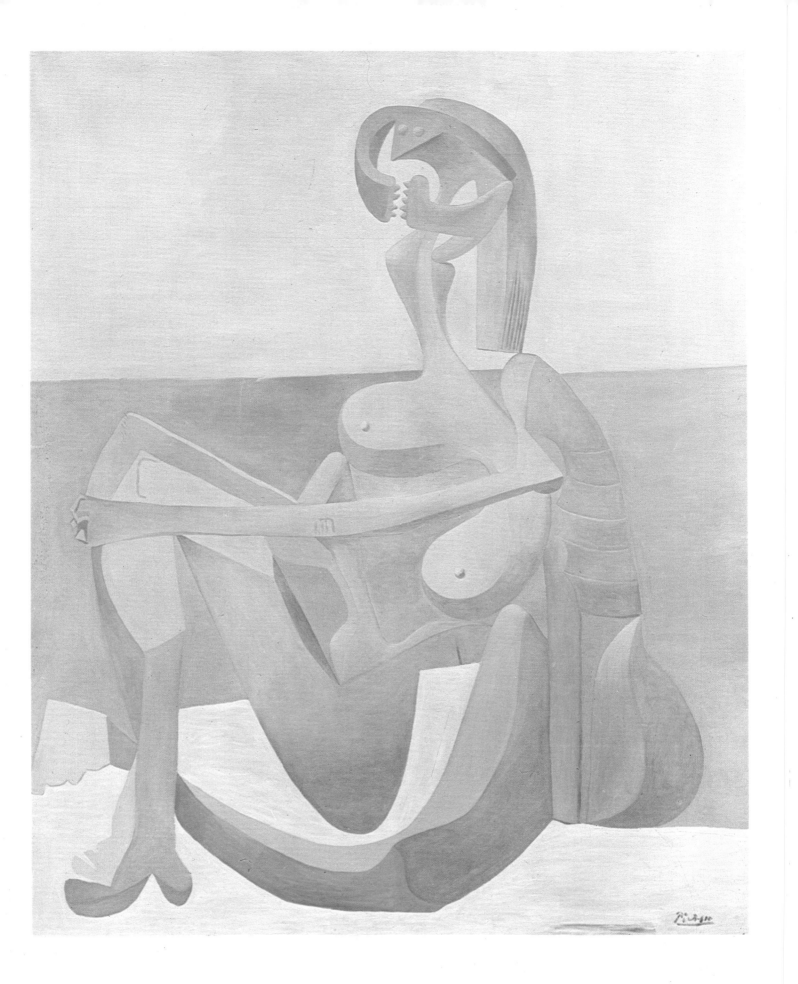

Figures by the Sea (The Kiss)

1931. Oil on canvas, 130.5 x 195.5 cm. Musée Picasso, Paris.

Picasso was not subdued by the attacks of an erstwhile ally (see discussion of Plate 33). In 1931, the year of Waldemar George's broadside against him, Picasso painted two of the most monstrous figures in his entire oeuvre. *Figures by the Sea (The Kiss)* is once again set against an expanse of Mediterranean sea. This time, however, Picasso may have had in his sights Rodin's great monument to sensual love.

An amorous embrace turns into a lethal duel between two combatants who seek to devour eachother. Their dumb animal heads have no eyes with which to see (love is blind!). Their flailing limbs are shaped like ribs, skeletal and deathly, but spongy and turgid at the same time. In his article on the praying mantis, Roger Caillois made note of the propensity of the female mantis to devour the male in coitus; the interest of this trait derives, he says, from the link it establishes between death and making love, from our 'ambivalent presentiment to find one in the other'.

In 1933 Picasso filled a sketchbook with drawings of figures coupling. This time the body undergoes a complete metamorphosis into a segmented insect. The same year the more whimsical invented *An Anatomy* (Fig. 33) was reproduced in *Minotaure*. These are obviously indebted to the surrealist assemblages of Alberto Giacometti.

Fig. 33
An Anatomy

1933. Pencil. Reproduced
in *Minotaure* 1, 1933.

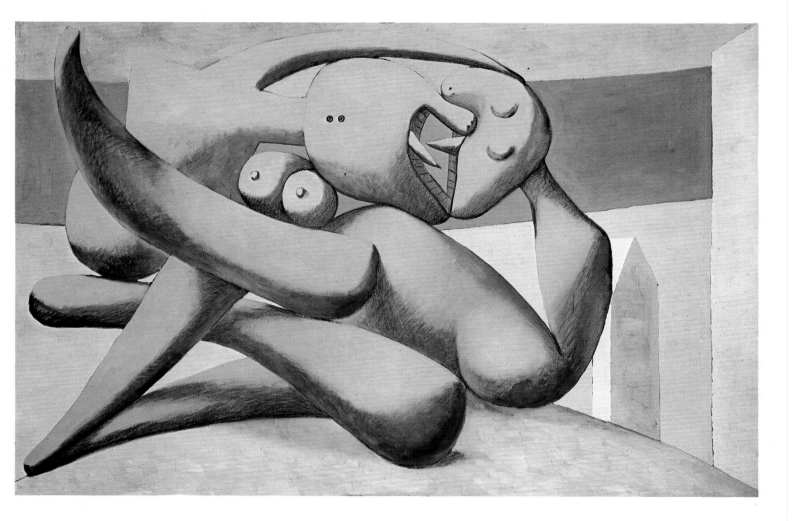

The Sculptor

1931. Oil on plywood, 128.5 x 96 cm. Musée Picasso, Paris.

The Sculptor is a complex picture. It includes many different ways of visually representing reality: stippled dots that refer to neo-impressionist painting; at the lower right is a *trompe-l'oeil* imitation of marble; the floorboards suggest a perspectival space but this is contradicted elsewhere. The main contrast, however, is between a classical bust opposite the artist and a surrealist figure, composed of rounded organic shapes, that rests on a pedestal between them.

At the centre of this topsy-turvy world sits the contemplative sculptor, whose head combines two distinct views: profile and full face (Janus-faced, he looks simultaneously at the bust opposite and at the viewer). In other words the sculptor himself seems to have a dual nature like his two sculptural creations. Indeed, as his right arm metamorphoses into an octopus one realizes he is the sea-god Proteus – or Picasso who could be classical and surrealist all at once. (When he spoke about his frequent changes of style, it is clear that Picasso considered himself a kind of Proteus.)

In 1927 Picasso produced several etchings on the theme of artist and model in the studio, to illustrate Balzac's fable *Le Chef d'oeuvre inconnu*, which was published in 1931. The theme was taken up again in 1933 in the *Vollard Suite* of etchings.

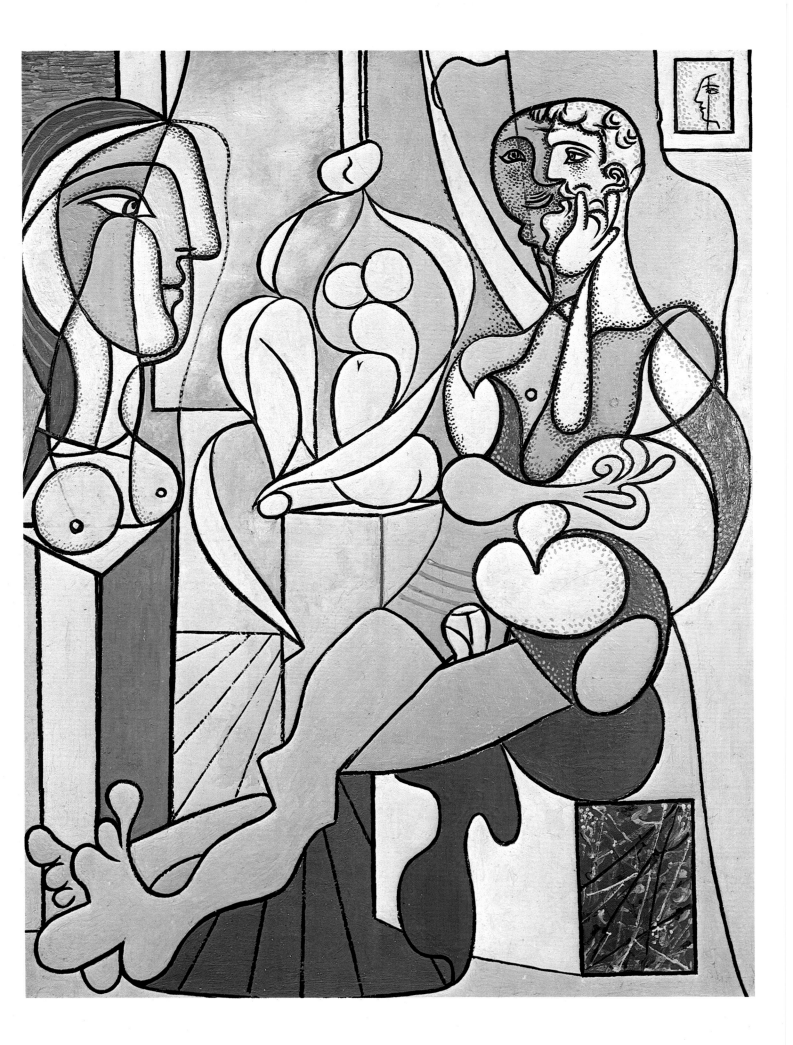

Nude Woman in a Red Armchair

1932. Oil on canvas, 130 x 97 cm. Tate Gallery, London.

Picasso did not just respond to the austere frozen classicism of Ingres (Fig. 31). He was alert to the undertow of erotic fantasy in Ingres' vision of the Orient, to the waxy flexibility of odalisques who, in the words of Robert Rosenblum, 'bend and twist to demands that mix the aesthetic and the erotic'. Looking back to this source, Matisse had conspicuously revived the odalisque theme in the decade after the First World War.

In *Nude Woman in a Red Armchair* Picasso transforms his young mistress, Marie-Thérèse Walter, into an Ingresque odalisque but eschews all trace of orientalism: femininity itself appears as the exotic and alluring other. The marble-white flesh of the woman is tinted violet to heighten her aura of mystery. Picasso filters the audacious distortions of Ingres through a surrealist lens: voluptuous thighs held in a desirous embrace by the scroll shaped 'arms' of a chair, and breasts which become ripe fruit, while the arms seem to germinate like plants. Linda Nochlin remarks with approval that Picasso conjures a 'grand cycle of procreation': desire, fertilization and growth. Less charitably, one might observe that the vegetal metaphor arises out of his passive and pliant fantasy of the female body.

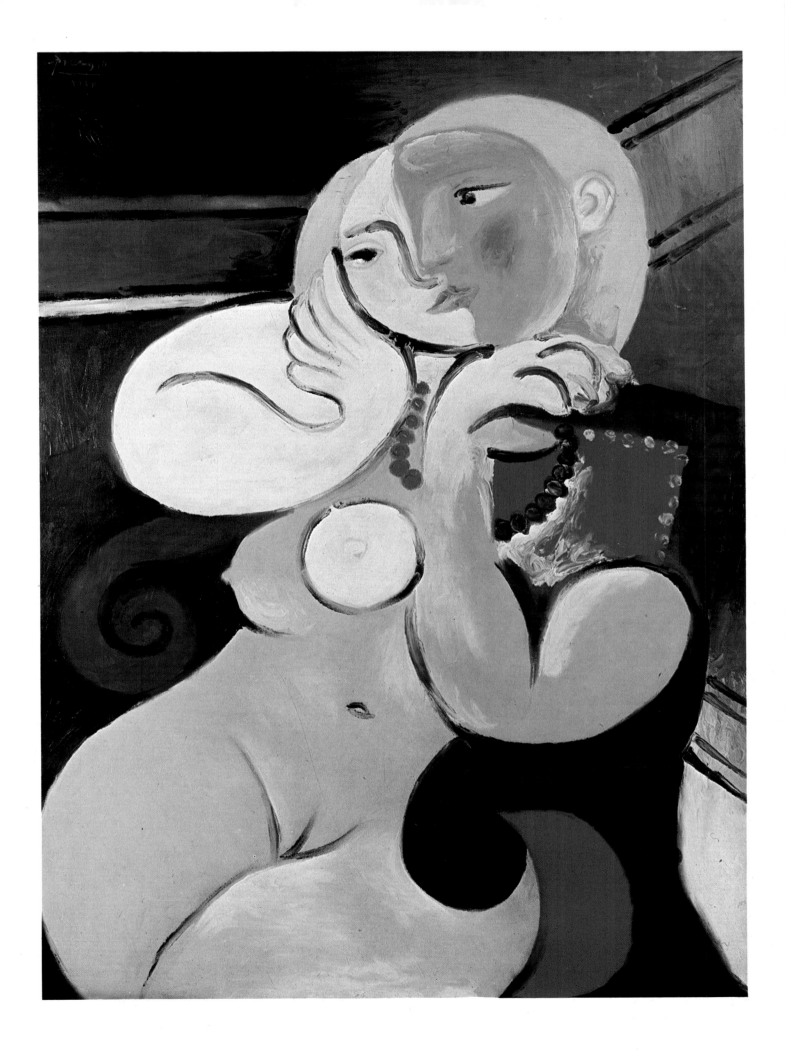

1932. Oil on canvas, 130 x 97 cm. Collection Mr. and Mrs. Victor W. Ganz, New York.

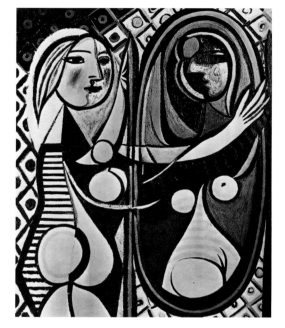

Fig. 34
Girl Before a
Mirror

1932. Oil on canvas, 162.5
x 130 cm. The Museum of
Modern Art, New York.

This picture tackles a subject dear to surrealism: the dream state. The sleeping Marie-Thérèse Walter is shown transported by an erotic reverie. An undulating contour that flows downward from the head through the shoulder, necklace and arm (and echoed in a wave pattern that criss-crosses the bodice) conveys the process of submersion in the unconscious.

Carl Jung observed in 1932 that, 'In Picasso's latest paintings, the motif of the union of opposites is seen very clearly in their direct juxtaposition.' The head of *Woman Asleep* combines a profile and full face view; the model is both dressed and undressed; the background is divided into halves. Linda Nochlin adds that the violet tint of her body 'is itself a product of mingled oppositions', a mixture of red and blue. The duality of sleep and wakefulness played out by the image brings to mind André Breton's famous definition of surrealism: 'I believe in the future resolution of these two states, dream and reality, which are seemingly so contradictory, into a kind of absolute reality, a *surreality*...'

Girl before a Mirror (Fig. 34) further exemplifies Jung's 'motif of the union of opposites' by juxtaposing a girl and her mirror image. Carla Gottlieb has remarked that a mirror of this type is called a *psyché*, so that Marie-Thérèse is actually gazing into her psyche – into the unconscious.

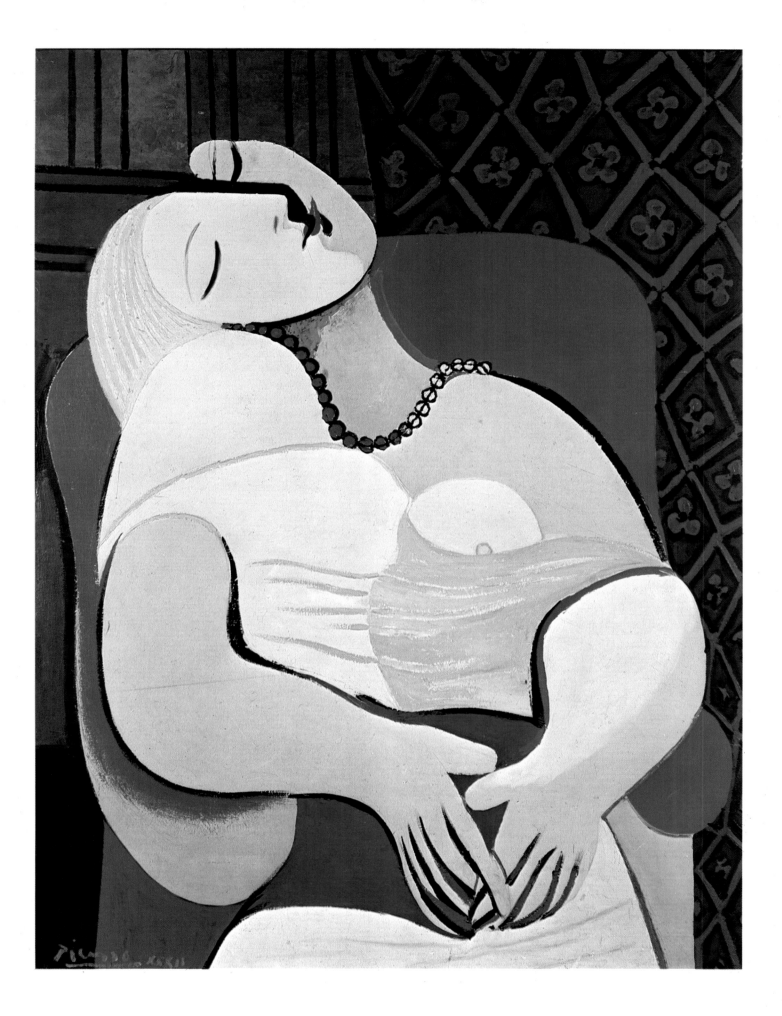

1935. Oil on canvas, 130 x 165 cm. Musée National d'Art Moderne, Centre Georges Pompidou, Paris.

The motif of a young woman drawing first appears in two isolated drawings in 1933 and arises from the theme of the male artist in the studio (see Plate 35). One might be perplexed by its appearance since, with this exception, artistic creation is an emphatically masculine activity in Picasso's work. It seems probable, however, that the female is present in a merely allegorical capacity, as an allegory of painting. In *The Muse* a second somnolent woman is added to the first, who gazes into a mirror. Their hands are shaped like ears of wheat, reiterating the association of femininity with a creative, vegetal unconscious (see Plates 36 and 37).

The Muse idealizes the studio as a tranquil refuge from the outside world, which is blotted out by a screen. Creative activity is presented as solipsistic and enclosed. In fact the 'ivory tower' of modern art was under attack in 1935. Some artists, concerned by the menace of fascism, had abandoned supposedly esoteric modern art to paint in a more accessible and politically efficacious manner. The crisis for Picasso was how to respond without either giving up modern art or reducing it to an art of propaganda. His triumphant resolution to this dilemma was *Guernica* (Fig. 1).

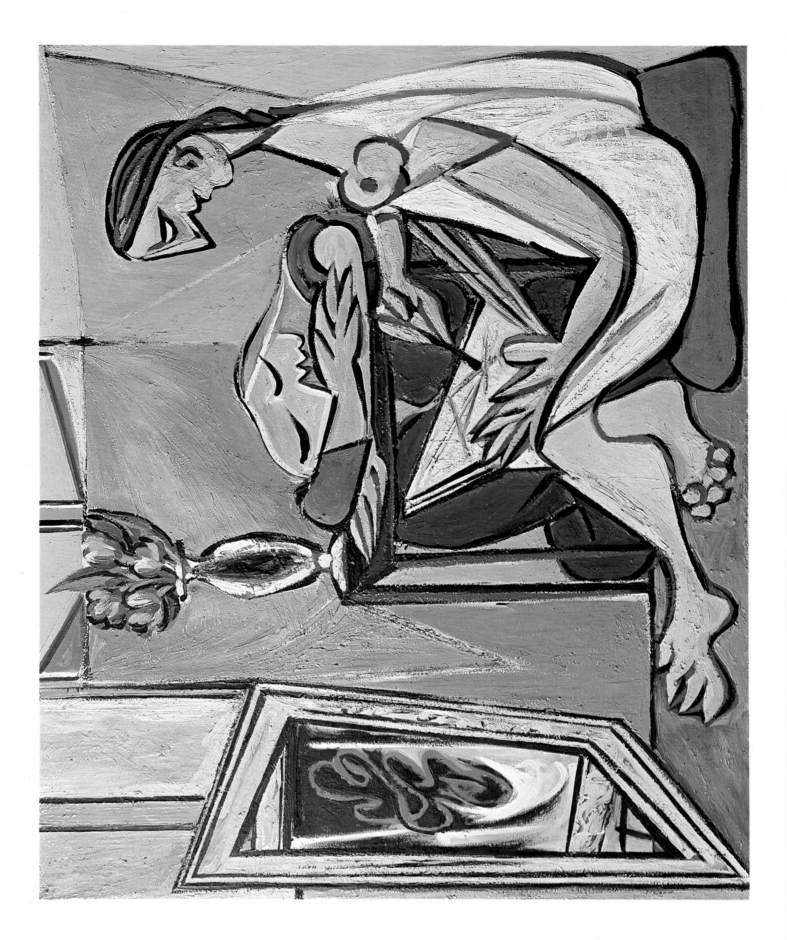

Weeping Woman

(Detail of Fig. 11). 1937. Oil on canvas, 54 x 44.5 cm. Tate Gallery, London.

Weeping Woman, painted after *Guernica*, is generated from a sequence of drawings for the head of a distraught woman which show the human face so distorted by emotion as to become grotesque. Picasso obsessively delineates each detail of the inside of a mouth opened to emit a rending shriek; some of the studies show the face as baboon-like. Together this 'chorus of mourners' is an almost intolerably concentrated expression of the inhumanity of war.

If anything, the effect is intensified in *Weeping Woman*. The refined palette of the preceding plates reaches a jarring expressionist pitch. Attention falls first on the open crying mouth and on the fingers, framed by the edges of a handkerchief. This section, like a picture within the picture, is filled with zigzag rhythms. These shock waves literally explode the equanimity of an elegant Parisian woman, who gives vent to an ocean of tears; indeed her eyes are like tiny boats tossed on a turbulent sea. As the shock ripples outwards it even buckles the surrounding space.

Weeping Woman depicts the moment of impact, when the horror of war is registered by someone who has witnessed from afar the atrocities being committed in Spain. It was intended to mediate our outrage at an event – the bombing of Guernica – that Picasso had represented earlier.

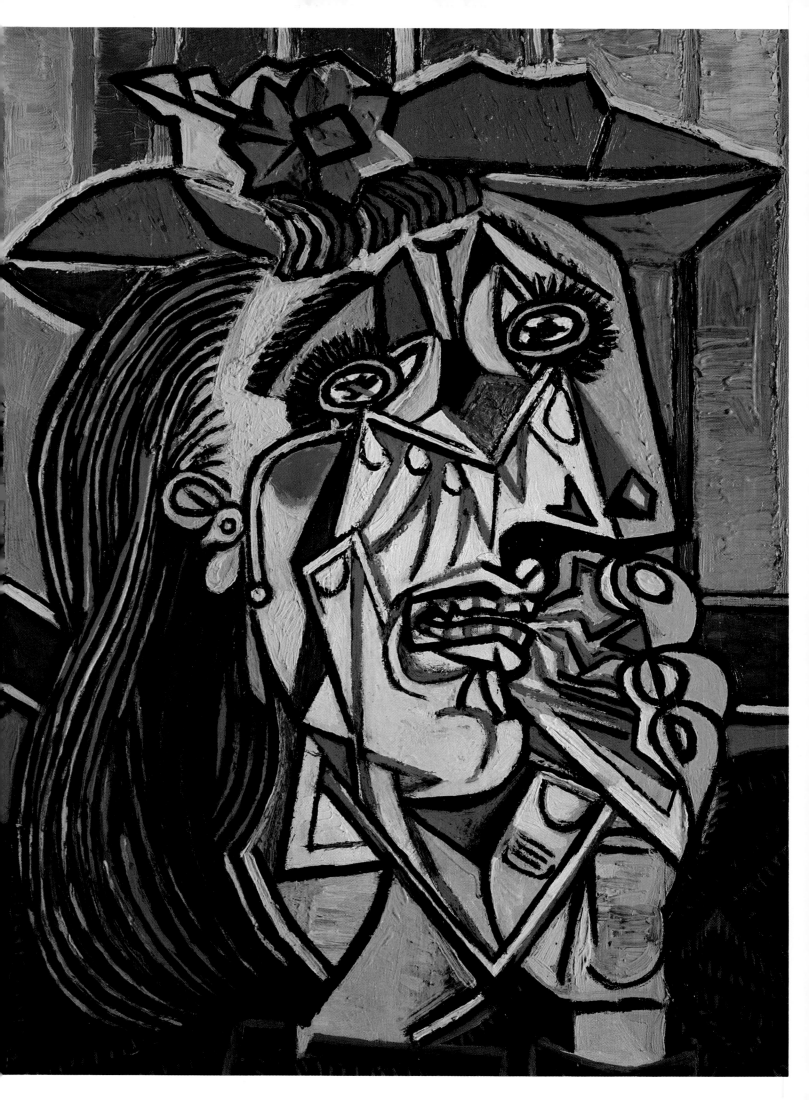

Cat Devouring a Bird

1939. Oil on canvas, 97 x 129 cm. Collection Mr. and Mrs. Victor W. Ganz, New York.

Cat Devouring a Bird was painted at an ominous juncture in European history: in January 1939 Barcelona surrendered to Franco's forces and in September the German war machine rolled into Poland.

A fearsome cat disembowels its pathetic victim with teeth and claws (excoriations on the surface of the canvas mime this aggression). All its terrifying lust for violence is concentrated in the expression of its head which is, as Roland Penrose notes, 'at the same time ferociously animal and disquietingly human'. The once proud rooster, ignominiously upturned, lets out a last shriek before succumbing to a frenzied attack. The whole drama takes place on a rooftop and is viewed from underneath, so the cat appears hugely magnified. Armed with camouflage stripes, it looms before us like an unstoppable juggernaut (the spaces between its limbs are shaped like axe blades).

A cat curled up at a fireside is a cosy image of domesticity. But in a moment this placid domestic creature can transform into a vicious and relentless hunter. It is this eruption of brutality from within the civilized that enables Picasso to extract from the scene such a convincing symbol for the homegrown beast of fascism, soon to be unleashed on France itself (though we should perhaps hesitate before reading the cock as a specific reference to the latter). In *Guernica*, the bull had been used to personify, in an equally ambivalent manner, the power of evil.

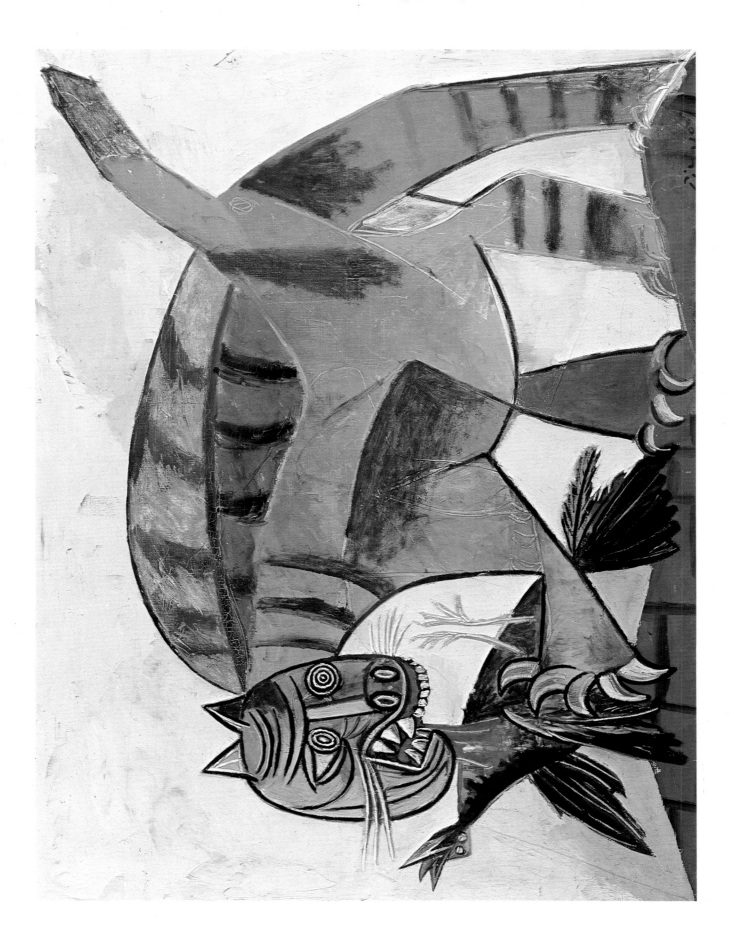

41 Woman in a Fish Hat

1942. Oil on canvas, 100 x 81 cm. Stedelijk Museum, Amsterdam.

The human physiognomy is subjected to quite extreme rearrangement in Picasso's work during the years of the German occupation. This can be very disturbing, as if the actual flesh of the model had been pummelled and carved. One suspects that, by their perverse cruelty, these images accurately reflect the ugliness of life at that time. Sometimes, however, the heads are unexpectedly lyrical, even comical.

Portraits of Dora Maar span this broad emotional range: in *Weeping Woman* (Plate 39) she was transfigured by uncontrollable grief, whereas *Woman in a Fish Hat* is at first glance an entirely whimsical image. The fanciful conflation of still life and portrait was first envisaged by Picasso in a drawing of 11 March 1939, where he created three equally bizarre hats – one with a lamb chop and crossed knife and fork decorating the brim. It may be that the later painting of a fish hat has something to do with the system of food rationing that was operating in Paris.

Pierre Daix regards the picture as a humorous release of tension. But Dora Maar – with her ashen complexion and edgy glance, pursed lips and hands firmly clasped in her lap – is *herself* a picture of tension. And the humour is not without a malicious streak: the large snout of the sitter belonged to the artist's Afghan hound, Kasbec!

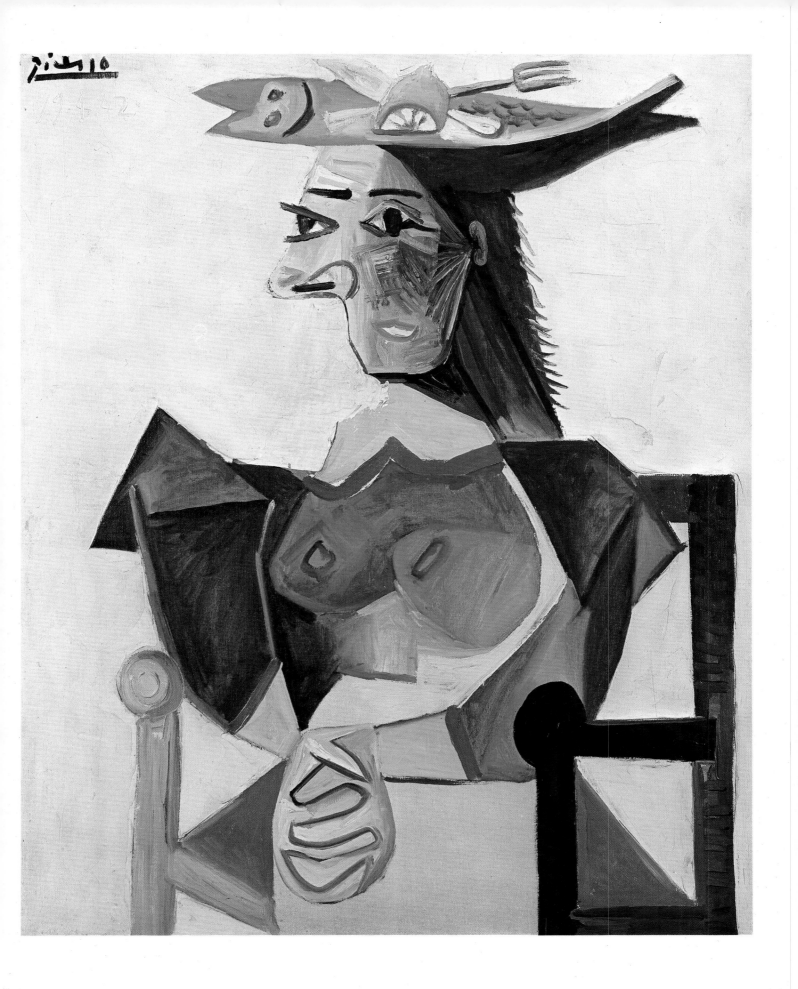

Pitcher, Candle and Cassserole

1945. Oil on canvas. 82 x 106 cm. Musée National d'Art Moderne, Centre Georges Pompidou, Paris.

Although Picasso was first and foremost a painter of the human figure, the genre of still life was crucial at certain moments in his work. This was so during the Second World War. *Pitcher, Candle and Casserole* was painted after the liberation, but its austerity alludes to the severe privation which was a daily fact of life under Nazi occupation. Its purpose is commemorative, the candle being a reminder of death.

The unglamorous objects, chocolate brown table and dusky wall bring to mind the unadorned realism of the seventeenth-century Le Nain brothers. The freedom to distort natural appearances bestowed by cubism has not been eschewed: the two edges of the table, which diverge rather than converge as they recede, hark back to the cubist break with perspective. The haunting quality of *Pitcher, Candle and Casserole* is partly due to the anthropomorphic aspect of the utensils, especially the pitcher. While Picasso was alert to the metamorphic potential of inanimate objects from early on, as a still life with a pitcher from 1919 shows, this becomes more explicit after the emergence of surrealism.

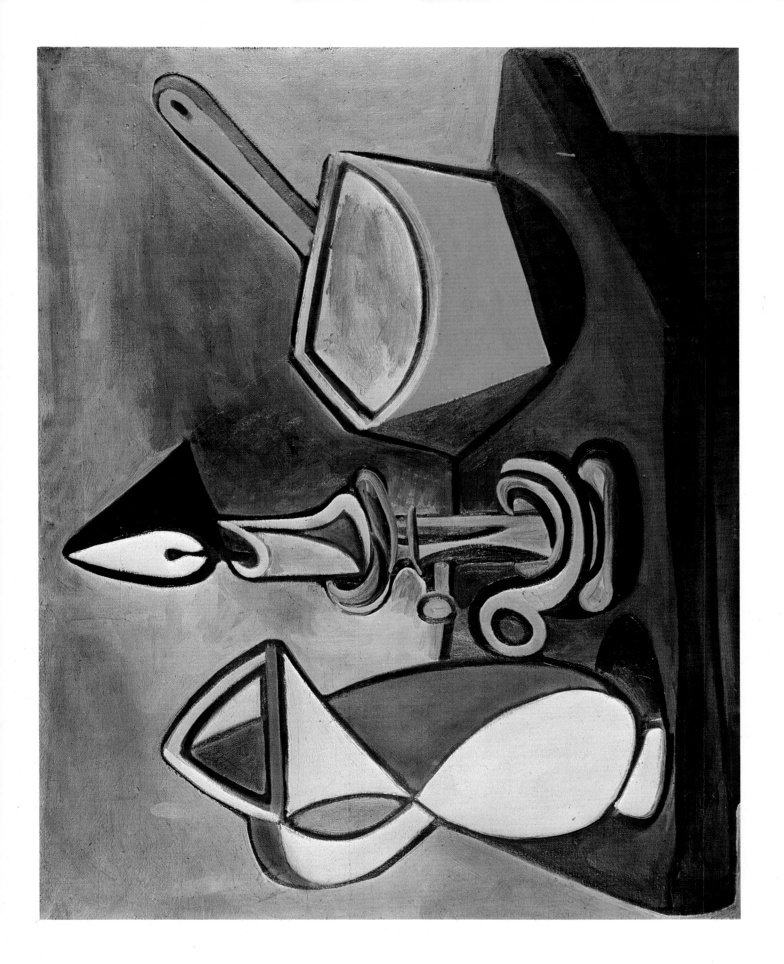

43 Woman on the Banks of the Seine, After Courbet

1950. Oil on plywood, 100.5 x 201 cm. Kunstmuseum, Basel.

At all periods the art of Picasso resonates with an acute historical awareness. This was most notable in the years after the First World War (see Plate 27). When this engagement with the past is resumed in later years it takes the form of a personal dialogue with the Old Masters.

Picasso takes as his starting point a picture by Gustave Courbet, *Les Demoiselles des Bords de la Seine*, that depicts two partly undressed courtesans resting at the edge of the Seine. Behind them is a punt moored to the bank. Their absent clients are perhaps, by inference, in the position of the spectator. It may be that Picasso recognized affinities with his own *Demoiselles d'Avignon*.

In reworking it he embellishes the Courbet with a rich decorative style first used in a remake of El Greco's *Portrait of a Painter*. The colour scheme also points to El Greco (his painting was a major influence on *Les Demoiselles d'Avignon*). If so, two stranger bedfellows could not be imagined: a Spanish court painter of the seventeenth century who painted in a highly stylized manner, and a nineteenth-century radical socialist whose name is synonymous with realism. For Picasso it was possible to encompass both these artistic alternatives. In his lifestyle, too, he lived out this curious alliance: as a member of the Communist Party and a multi-millionaire living in a castle.

44 Goat's Skull, Bottle and Candle

1952. Oil on canvas, 89 x 116 cm. Tate Gallery, London.

Goat's Skull, Bottle and Candle is a painting of an assemblage sculpture which Picasso made in 1951-52. There may be an intrinsic connection between still life, *nature morte*, and death. Certainly the *memento mori* is one of its major themes. Spain has a rich tradition of still-life painting that Picasso drew upon.

The goat (Fig.35) typically personifies lechery, but its meaning switches here to a grim reminder of mortality. The candle, a standard symbol of transience and a source of light contrasted with the skull, is also ambiguous: on closer examination it appears to cast more shadow than light and the rays are like sharp protruding nails.

Thus a picture that at first glance appeared to be a simple contrast of black and white is in fact composed in rich shades of grey. Picasso shows how even the most hackneyed symbols are unstable in meaning, and may actually reverse into their opposites. At the level of pictorial structure he similarly contrives rich spatial ambiguities, employing a late cubist idiom to do so. In this and the previous plate thick lines produce the effect of a stained glass window.

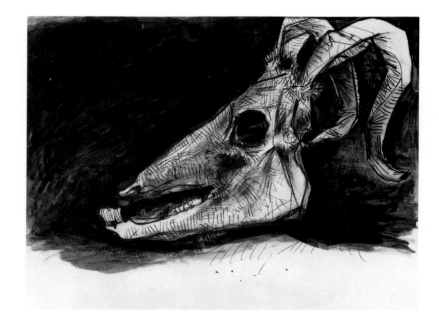

Fig. 35
Goat's Skull

1951. Pen and ink with wash. 50.5 x 66 cm. Birmingham City Museum and Art Gallery.

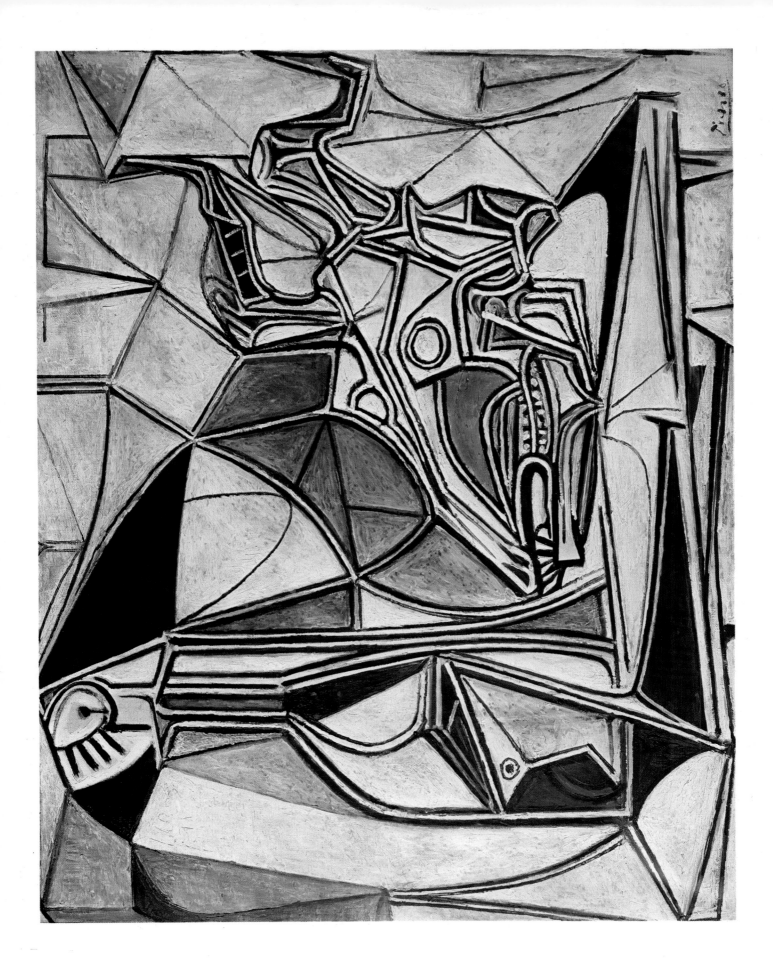

The Smoker

1953. 188 x 153 cm. Sold Christie's New York, 10 May 1989.

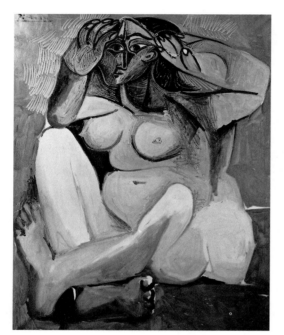

Fig. 36
Seated Female
Nude

1956. 101 x 77 cm.
Museum of Fine Arts
(Intended gift Mr. and
Mrs. Daniel Saidenburg),
Boston.

In the years immediately following his death, the late works of Picasso were held in fairly low esteem, but this has now changed. The tendency of recent painting to pastiche the art of the past has meant that Picasso's reworkings of the Old Masters now seem much more 'relevant'. Similarly the late nudes, with their very raw facture, are suddenly in tune with the figure painting of the 1980s.

The vitality and *éclat* of many of Picasso's late works are comparable to Van Gogh. *The Smoker*, with its saturated primary colours and vigorous paint handling, gains in boldness what it evidently lacks in subtlety. The elephantine limbs have an almost comical monumentality. Picasso exaggerates the combined profile and full face views, so that the smoker looks uncertainly in both directions at once.

Seated Female Nude (Fig. 36) also sacrifices elegance for something more elemental, just as Picasso had done as he embarked on *Les Demoiselles d'Avignon*. Indeed, the parallel scarification marks around the head may hark back to this period; they also relate to the gouged lines of linocut – some of the most striking of the late works are in this medium.

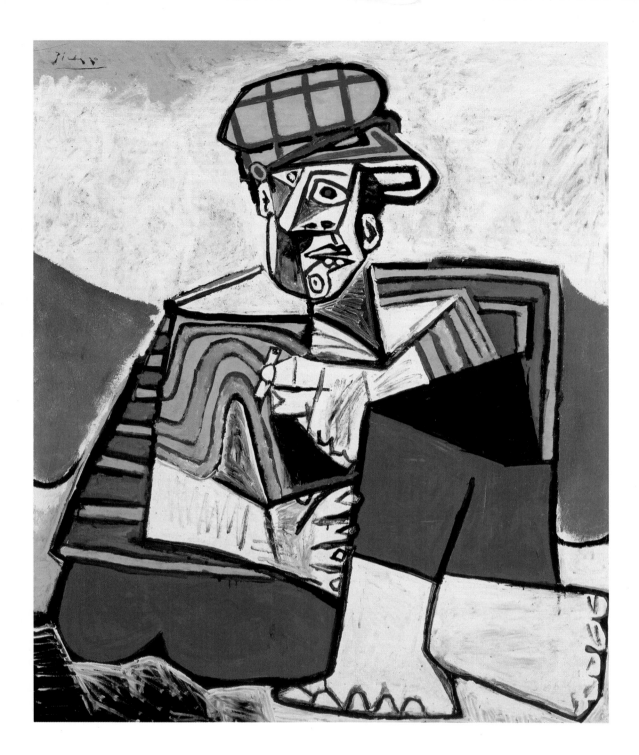

1955. Oil on canvas, 114 x 146 cm. Collection Mr. and Mrs. Victor W. Ganz, New York.

Picasso told Roland Penrose that, 'when Matisse died he left his odalisques to me as a legacy, and this is my idea of the Orient, though I have never been there.' Matisse died on 3 November 1954. Soon afterwards Picasso embarked on a series of fifteen variations on Delacroix's *Women of Algiers*, ending on 14 February 1955 with the picture illustrated here.

Delacroix was not merely a source for the odalisque motif. He was also a progenitor for the French colourist tradition to which Matisse was heir. Picasso, on the other hand, tended to be typecast as an artist concerned less with colour than with form (a result of his development of analytic cubism). The legacy Matisse bequeathed to him was thus an artistic tradition originating with Delacroix – to whom Picasso returned. Matisse and Picasso were great rivals, as is evident in the ambivalent character of his homage.

In some of his variations on the *Women of Algiers* Picasso leaches its sumptuous colour away, destroying the image. When colour is allowed to return in the final state it is incorporated into a cubist space that belongs wholly to Picasso. The violent contest that an artist wages with his forebears is forcefully shown in the series (Fig. 13) Picasso made after *The Rape of the Sabines* by Jacques-Louis David. The two male warriors can be read as Picasso and his precursor, David. This oedipal scenario is enacted over the body of the mother.

It is said that the hieratic odalisque on the left of Picasso's *Women of Algiers* is Jacqueline, his last wife. She would inspire the torrential outpouring of late nudes.

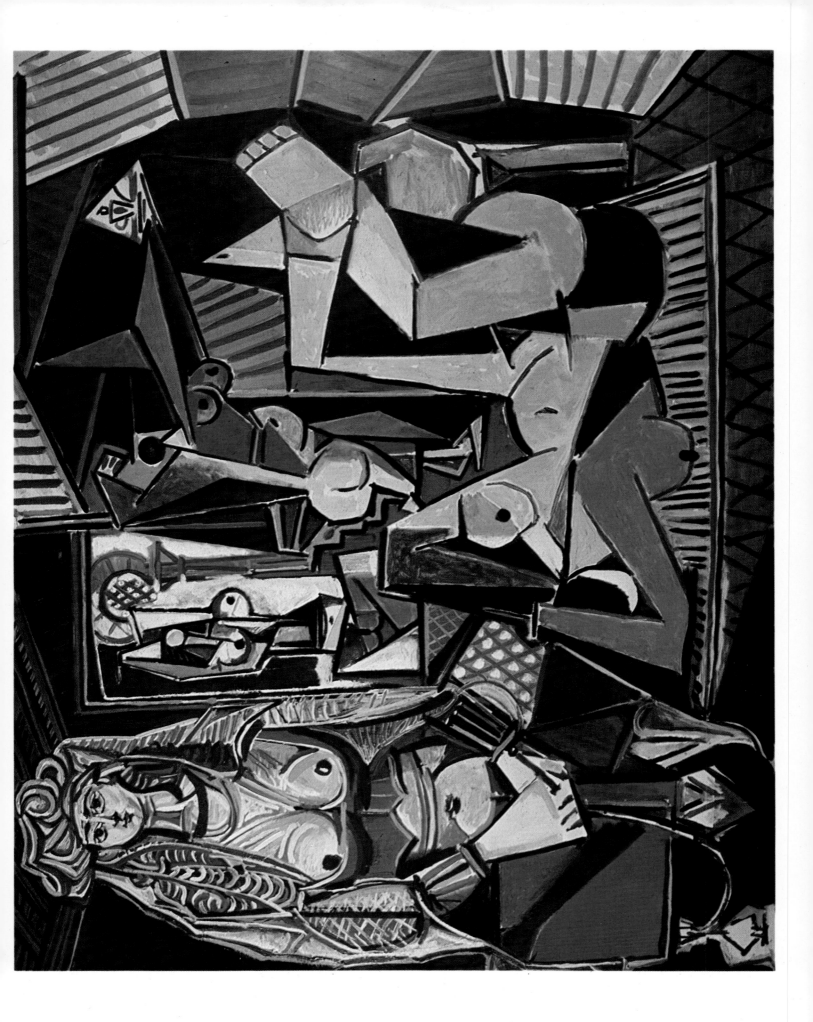

47 a) Ceramic plate, decorated with a goat's head

b) Spring

1956. Oil on canvas, 130 x 195 cm. Private Collection, Paris.

Scattered ruins of Roman civilization and a congenial climate make the south of France, where Picasso returned after the sombre war years, especially suited to portrayal as a mythic paradise. At Antibes in 1946 Picasso created an Arcadia redolent of Matisse and populated it with nymphs, fauns and centaurs. *Spring*, in which a faun slumbers beneath a tree in the midday sun while a goat picks at a fresh sprout, typifies the carefree spirit of these works. Picasso, too, was prepared for a time to bask in his success, as a hero of the resistance and the most famous modern artist.

At Vallauris, where pottery was a traditional craft, Picasso absorbed himself from 1947 in decorating ceramics, taking advantage of the connotations of painted earthenware to recreate a mythic Antiquity – a plate decorated with a quizzical goat happily marries the medium with the message. The ceramic pieces designed by Picasso were produced in series of up to 500 by local craftsmen at Vallauris; in the postwar years there was an enormous market demand for his work.

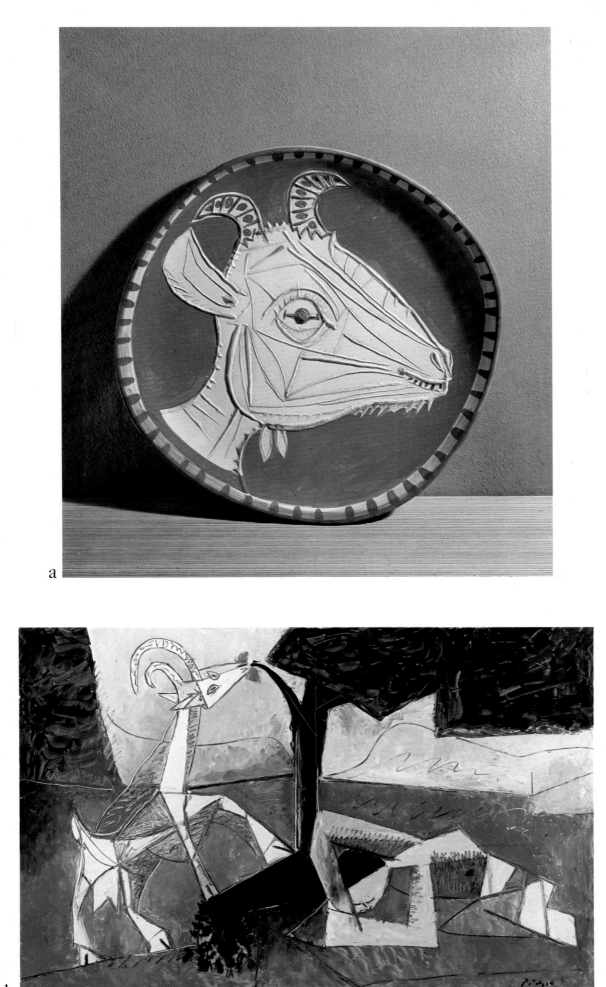

a

b

1963. Oil on canvas. Private Collection, Paris.

·

In old age, as the horizon of his world narrowed, Picasso reverted to the subject of the artist in the studio (see Plate 35). The focus now is upon the encounter of two protagonists: the artist and his female model, who generally bears a close resemblance to Jacqueline, Picasso's wife in his last years.

The Artist and his Model is divided into two zones by the edge of a canvas which forms an impregnable barrier between the painter and his voluptuous model. By a curious inversion he appears to be sightless while the alert model controls the gaze. All the warmth and passionate intensity of the picture resides on her side. The raised supports of the easel double as the head of a minotaur – the artist is also cut off from his former alter-ego.

The canvas divides the pair but it also unites them, metaphorically. The white flesh of Jacqueline *is* bare canvas, and so the act of painting is equivalent to touching or embracing her.

Picasso identifies with the bearded cavalier at the centre of Rembrandt's *The Night Watch*. As a stoical artist-soldier he is dedicated to the task of painting. Between the *Self-Portrait* of 1901 (Plate 1) and this, Picasso had earned his heroic image several times over.